# NEW ENGLAND
# COVERED BRIDGES
## THROUGH TIME

## JOSEPH CONWILL

AMERICA THROUGH TIME®

PHOTO CREDITS: The old photographs for this book were mostly drawn from the archives of the National Society for the Preservation of Covered Bridges and were taken by Richard Sanders Allen, Raymond Brainerd, Henry A. Gibson, Basil Kievit, John W. Storrs, or Daniel N. Wheeler. Several were drawn from old postcards in the author's collection, and some were taken by the author himself in years gone by. The new views are by the author, and most of them were taken on color film with a vintage Leica M-3 camera.

AMERICA THROUGH TIME is an imprint of Fonthill Media LLC

Fonthill Media LLC
www.fonthillmedia.com
office@fonthillmedia.com

First published 2014

ISBN 978 1 62545 078 4

Typeset in Mrs Eaves XL Serif Narrow
Printed and bound in England

Connect with us:
 www.twitter.com/USAthroughtime
 www.facebook.com/AmericaThroughTime

AMERICA THROUGH TIME® is a registered trademark of Fonthill Media LLC

# INTRODUCTION

Covered bridges are popular symbols of Americana. When they started disappearing from the New England landscape in the 1920s, tourists began photographing them enthusiastically. By the 1960s covered bridge preservation was a goal widely accepted throughout the region. But in the late twentieth century the rural economy transformed itself into a suburban one. People in New England commuted long distances to jobs elsewhere; their children went to consolidated schools on buses; their homes were heated with trucked-in oil; fire protection required heavy equipment. Fast high-volume traffic placed demands on the covered bridges which their original designers did not foresee.

The popular image of a changeless New England does not match this new reality, but the symbol is a potent one, and so long as there are covered bridges, the timeless image still seems credible. But the covered bridges and their surroundings have changed along with the times. The point of departure for this photographic journey will be the covered bridges as seen in the first half of the twentieth century by tourists, postcard producers, and historians. This was the time when the public began seeing the bridges as cultural attractions, rather than as outmoded eyesores. Some sites still look much as the early tourists saw them, but many have changed, even if the bridges themselves are still there.

The future cannot be predicted, but the cultural appeal of covered bridges will influence how they look. Few would have been saved at all except for the fact that so many people liked them. In the 1950s, however, the popular perception was that covered bridges were supposed to be red. Many were in fact painted red in the old days, but many were painted in other colors, and a very large number were never painted at all. Road crews began painting them red even when they had not been painted before, because this is what the public thought was authentic. The change was widespread in parts of Pennsylvania, which is rich in covered bridges, although less common in conservative New England.

Towards the close of the twentieth century, real-estate developers built imitation covered bridges everywhere, which were structurally inauthentic, and only vaguely resembled the historical examples. Several of these sported cupolas or dormers on top, for no reason except to declare that here was something unusual. But these modern structures have falsely influenced the public perception of the covered bridge, and in popular art we now see covered bridges represented with cupolas on top. This has scant relation with historical reality. Well more than ten thousand covered bridges were built in North America, but only a dozen or so had cupolas, and

they were nearly all railroad bridges where it was desirable to vent the smoke from steam engines. It will be interesting to see if proposals for future "repairs" to the old covered bridges will involve adding cupolas.

Preservation officials may veto the cupolas, but there are other more difficult questions involved in covered bridge restoration. The bridges were widely neglected in the early twentieth century, either from lack of funds, or because officials expected to replace them soon anyway. Wooden bridges had been covered in the first place to protect their trusswork from decay. Leaky roofs and missing siding caused serious structural damage. When the bridges finally became tourist attractions, many of them had suffered from the years of neglect.

What is the best way to correct this damage? Should the entire structure be saved by adding modern supports? Or instead should new timbers be sistered in as needed, keeping as much as possible of the old wood? Should partly-decayed members be replaced in their entirety, giving a neater appearance, but sacrificing much of the historical timber? Taking this approach to its logical conclusion would allow replacing the whole covered bridge with a modern copy, and this has in fact happened many times in New England. Often these all-new structures continue to be listed in the National Register of Historic Places as if they were old. Such treatment would be unthinkable with treasures such as Boston's Old State House, but it is widely accepted with covered bridges.

Changes to the surrounding landscape also affect our experience of the covered bridges. In the nineteenth century many of them served towns and cities, but these were among the first to be replaced, so when tourists began seeking out covered bridges in the 1920s, they found rural sites. Most of New England's covered bridges still served country locations into the 1970s. Afterwards, the checkerboard development patterns of the suburban conversion affected some sites much more than others. Everywhere the traffic volume is many times what it once was, although in appearance at least, many of New England's covered bridges still offer a rural atmosphere. This book does not show every one of them, but the changes illustrated here are representative of the covered bridges of the entire region.

# SOUTHERN NEW ENGLAND

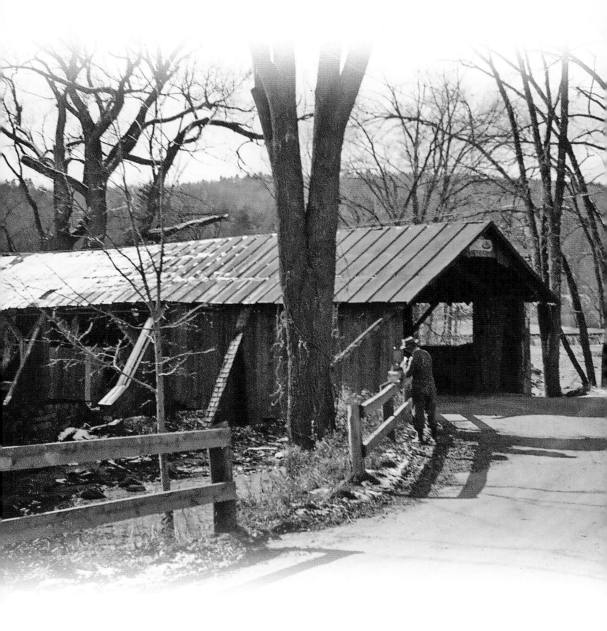

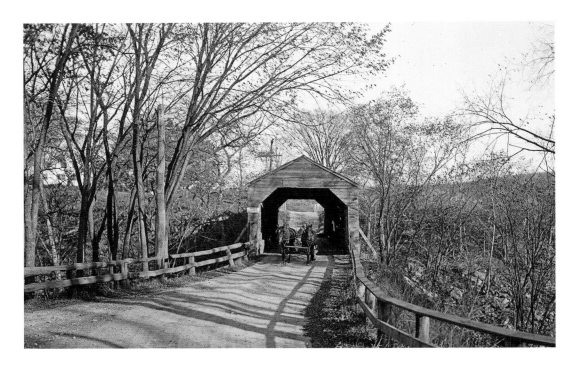

WESTERN CONNECTICUT LANDMARK: Bull's Bridge crosses the Housatonic River in the southern part of Kent, Connecticut, and is one of only two old authentic covered bridges remaining in the state. It has had serious structural problems over the years and uses modern reinforcement, but much of the original structure still remains.

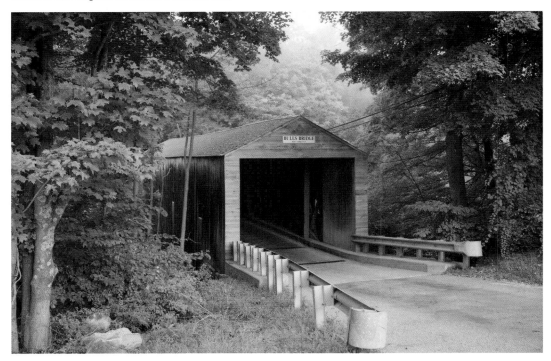

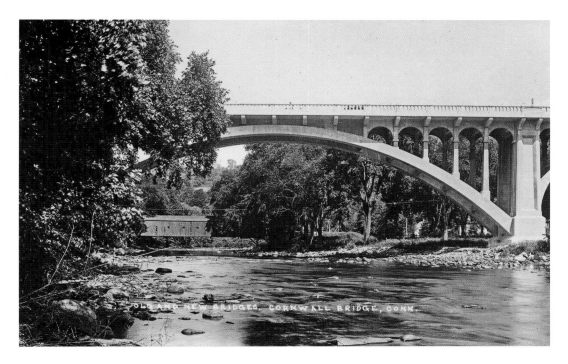

FORMER HOUSATONIC CROSSING: Cornwall Bridge, at the village of that name, also spanned the Housatonic. It was bypassed in 1930 by an attractive concrete arch bridge which is still in service on the high-level relocation of U.S. Route 7. The intent was to preserve the covered bridge as an historical landmark and for local traffic in the village, but it was destroyed in the flood of 1936.

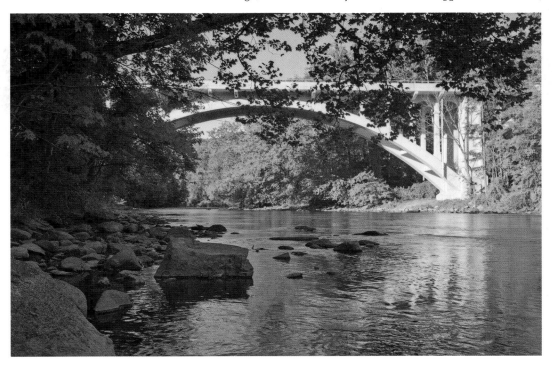

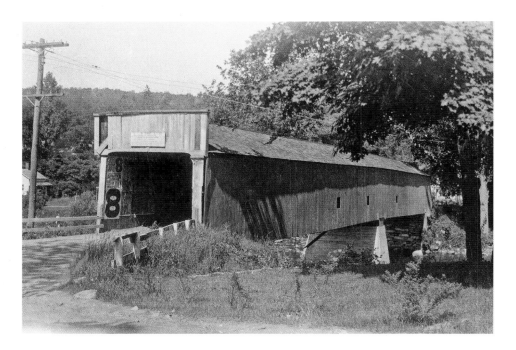

VISIBLE FROM U.S. ROUTE 7: Hart's Bridge, at West Cornwall over the Housatonic River, is Connecticut's other old covered bridge. A third, near East Hampton in the eastern part of the state, was torn down and replaced with a modern replica. The floor of Hart's Bridge has been reinforced by hidden steel beams, but most of the rest of the old structure remains, and it is one of only two New England covered bridges still in service on a numbered state highway.

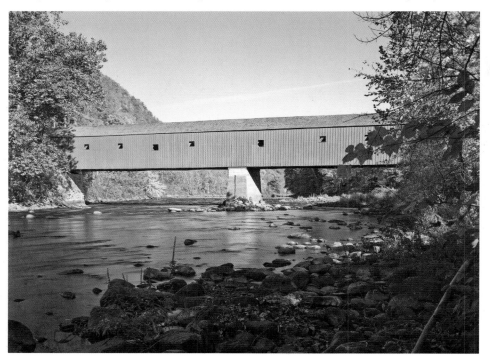

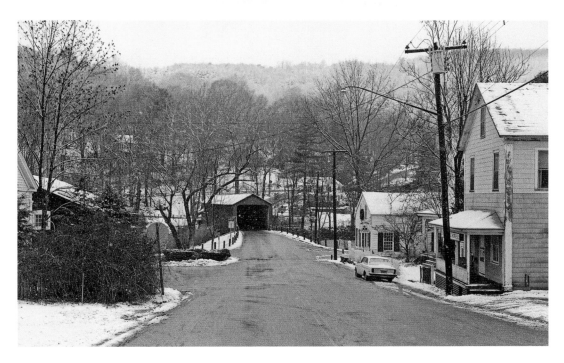

CENTERPIECE OF THE VILLAGE: Hart's Bridge enjoys a lovely setting in the midst of the village of West Cornwall. It once had a square false front portal, but during work in 1946 to repair overheight truck damage, it was re-boarded with a plain gable. False front portals of various styles were once common on covered bridges in southeastern Pennsylvania and were occasionally found elsewhere, but they have become very rare.

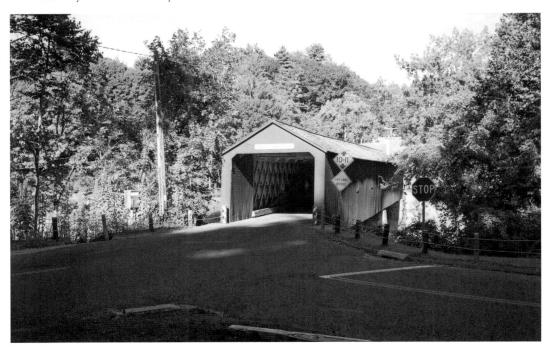

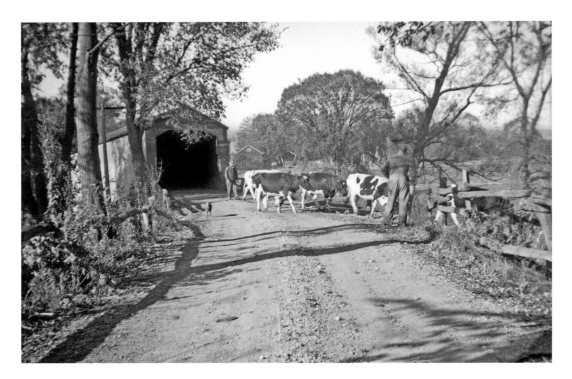

MASSACHUSETTS REPLICA: Upper Bridge also spans the Housatonic, but over the state line in Sheffield, Massachusetts. The original 1830s covered bridge was completely destroyed by arson in 1994 after a masterful restoration, and was replaced in 1998 with a copy. The more recent bridge is heavier in construction and could easily carry traffic, but it was closed for recreational use.

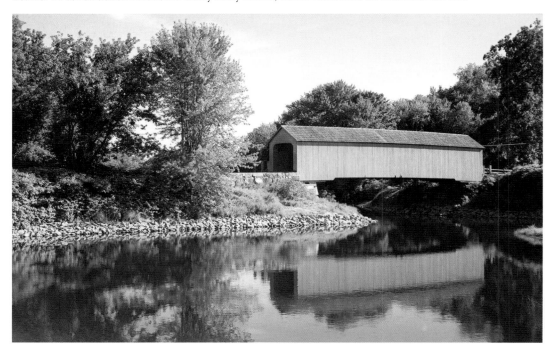

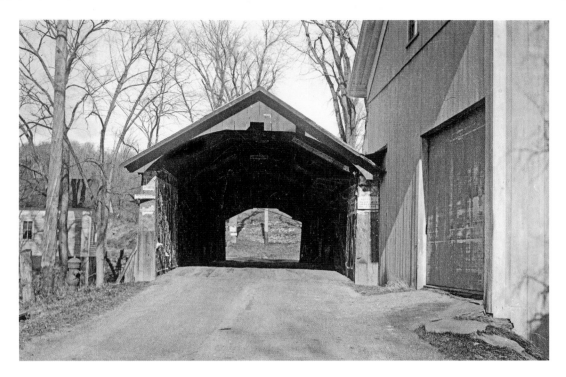

FORMER VILLAGE LANDMARK: This covered bridge at Cummington, Massachusetts crossed the Westfield River at the west edge of the village, on the beginning of the road to Plainfield. It was lost in 1938, but the large carriage house adjacent to its south portal stands (to right of parked car) as a reminder of the old days. Page 5 shows another view of this bridge.

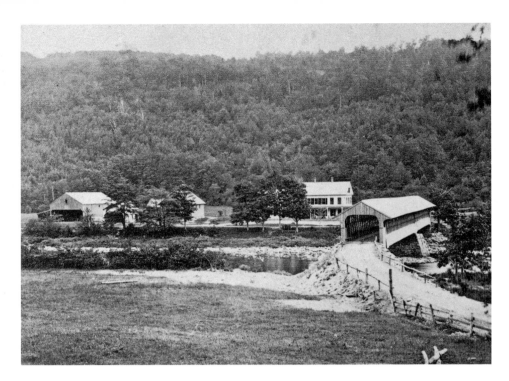

LONG-GONE DEERFIELD RIVER CROSSING: The covered bridge usually identified as "Hoosac Tunnel" crossed the Deerfield River about a mile downstream from the east portal of the famous railroad tunnel. Only the very early tourists got to see it, for it was replaced with the present steel truss in 1916. Although the trees have grown up, the site has changed surprisingly little since that time.

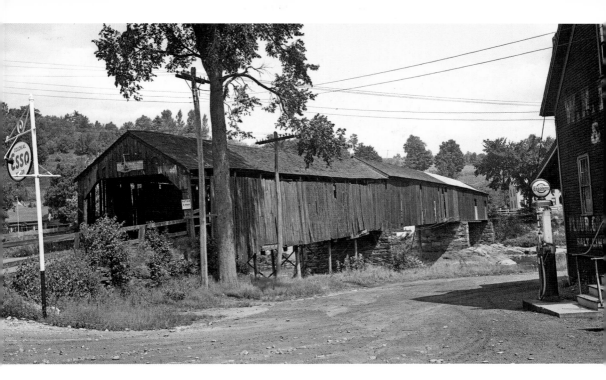

ALONGSIDE THE MOHAWK TRAIL: The Long Bridge at Charlemont offered a confusing picture to historians, because one of its three spans used a different construction style then the other two, the result of long-ago flood losses. It was very popular with tourists and stood adjacent to the heavily-traveled Mohawk Trail, Massachusetts Route 2, until being replaced with a newer bridge in 1944.

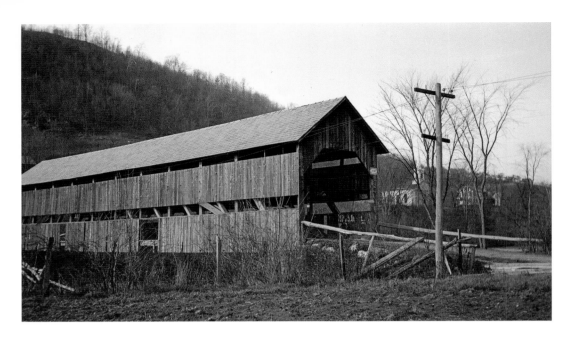

QUIET NORTHERN MASSACHUSETTS SETTING: Arthur Smith Bridge over the North River in Colrain connected the adjacent communities of Lyonsville and Foundry Village. The early view shows long windows in the side, but the bridge was long ago re-boarded, and for many years stood unchanged as a familiar landmark to visitors in this quiet and attractive area.

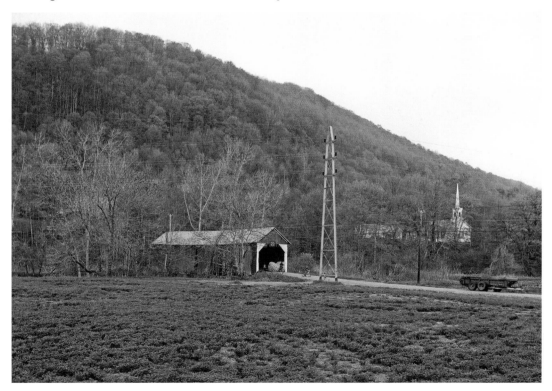

**ANOTHER RECENT REPLICA:** A comparison of the author's 1973 and 2013 views of Arthur Smith Bridge seems to show little change. In fact the old covered bridge was torn down and replaced with the existing copy in 2006. A very small amount of the original timber was re-used, so it is really an all-new bridge.

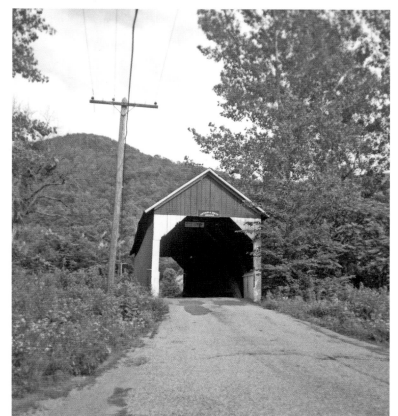

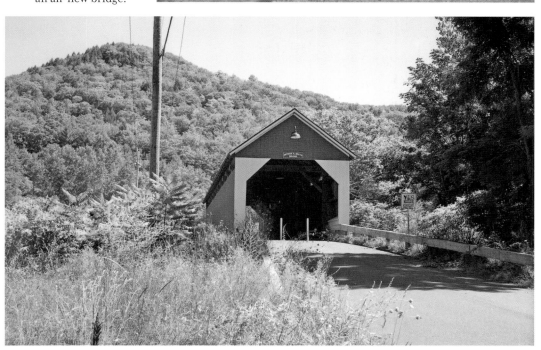

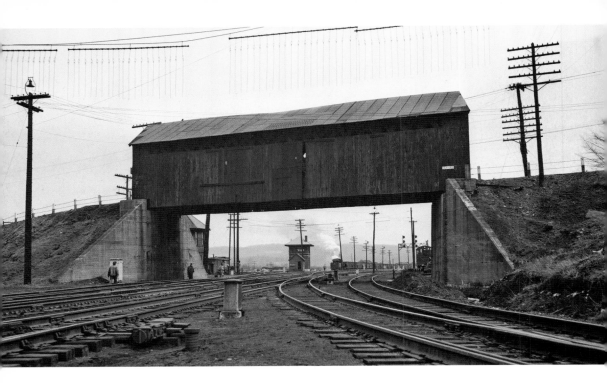

COVERED BRIDGE OVER THE RAILROAD: McClelland Bridge at the Boston & Maine railroad yards in East Deerfield was a rarity, an old covered bridge built to cross railroad tracks rather than a river. It was replaced in 1950, but the site is readily recognizable, and the rail yard is still in use.

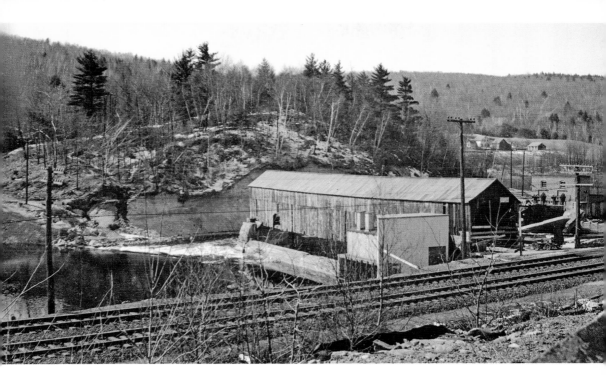

BRIDGE AT THE PAPER MILL: Erving Mills Bridge was built in 1857 to cross Millers River at Stoneville, in the east end of Erving. It was seriously damaged by floods in the 1930s and was gone by the end of the decade. The Erving Paper Mills are still active, longtime manufacturers of recycled paper products, but there is no longer a bridge at the site (at left in new photo).

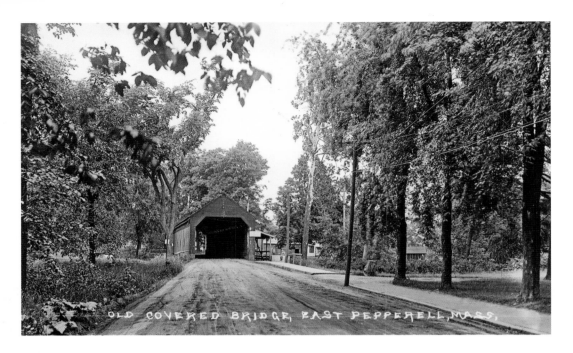

FORMER EASTERN MASSACHUSETTS BRIDGE: Jewett Bridge over the Nashua River at East Pepperell was the last remaining covered bridge in eastern Massachusetts. Sentiment led to its replacement in 1963 with a gigantic modern interpretation of a covered bridge, but the new bridge developed structural problems and was replaced with the present structure in 2010. Similar very large modern interpretations of the covered bridge concept have been built in Ohio.

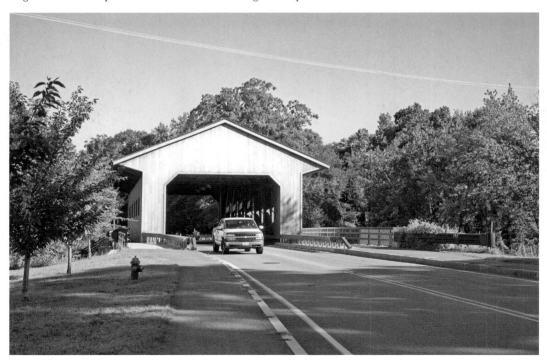

# VERMONT

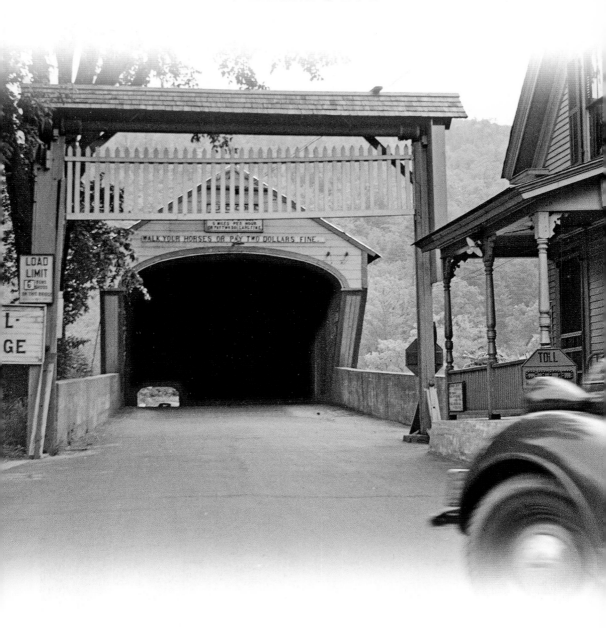

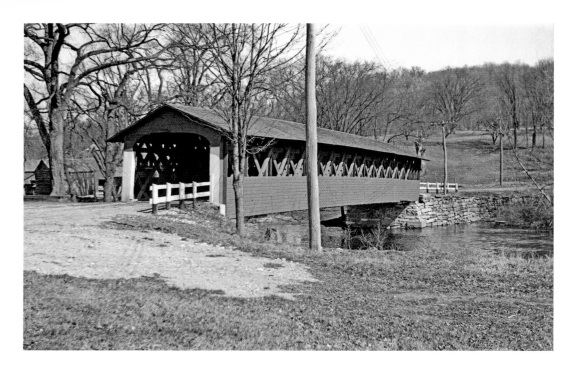

FAMOUS BENNINGTON LANDMARK: Vermont has more covered bridges than the rest of New England put together. Henry Bridge, over the Walloomsac River in Bennington, dated from around 1840. It was reinforced later with extra timbers which were removed during an overhaul in 1952, although many writers continue to describe the nonexistent timbers as if they were still there.

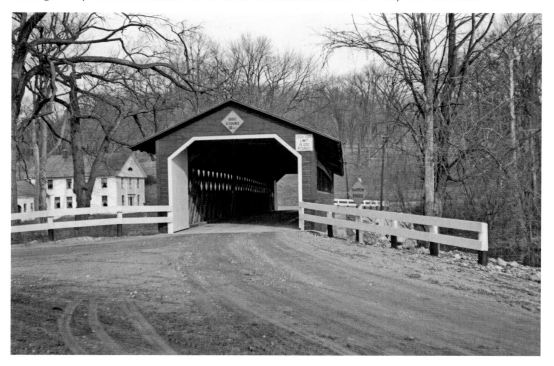

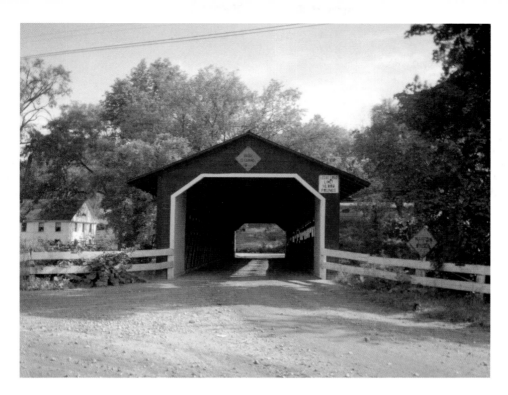

REPLACEMENT OF THE LANDMARK: The author's 1966 photo of Henry Bridge still shows a gravel road at a quiet site. Murphy Road has since been paved and there are steel guard rails instead of wooden fences, but more has changed than meets the eye. The old covered bridge was demolished and replaced with a modern copy in 1989, the first such total replacement in Vermont, and it set an example for a dozen similar jobs in New England since then.

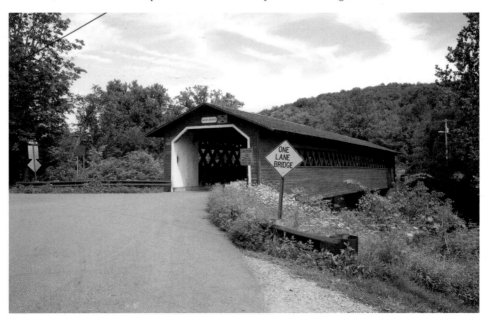

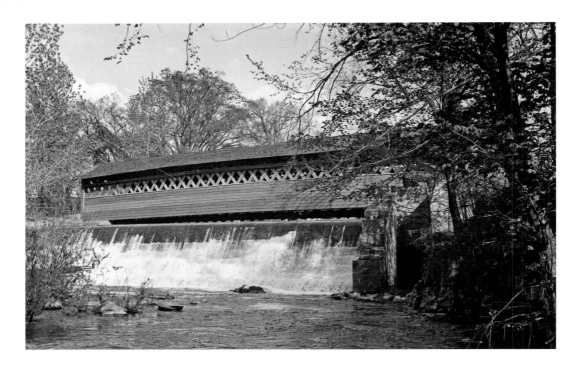

ANOTHER VERMONT REPLACEMENT: Paper Mill Bridge, just downstream on the Walloomsac, is another all-new covered bridge copy. The original 1889 bridge by Charles F. Sears was torn down and replaced with the present structure in 2000. The National Register of Historic Places continues to list the 1889 bridge as if it were still there, under the name of Bennington Falls Bridge.

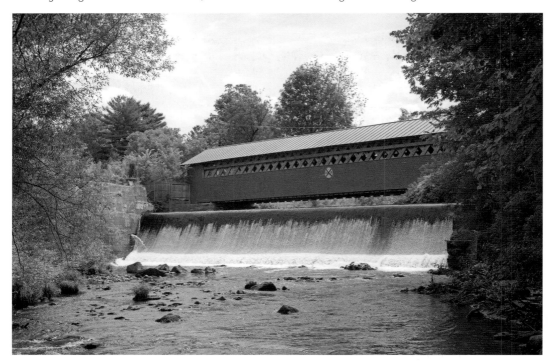

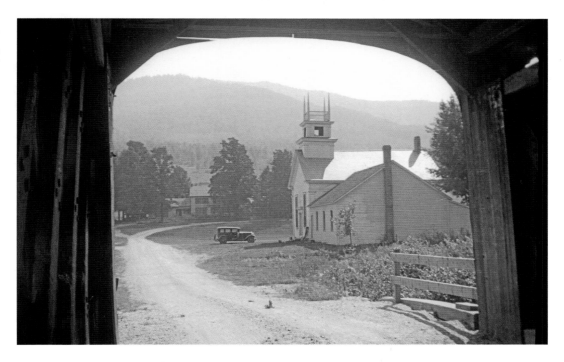

NORMAN ROCKWELL'S HOME VILLAGE:  The view from the covered bridge over the Batten Kill at West Arlington has changed little since Richard Sanders Allen's photograph in 1937, although the inside of the bridge has since been fenced with chain link to prevent people from pushing off the side boards for fishing or for diving. In the 1950s the bridge received a coat of red paint, but earlier photos show it unpainted.

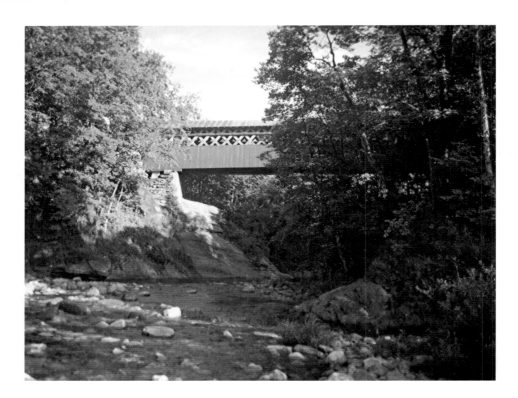

VIEW CHANGED BY CONCRETE PILINGS: Chiselville Bridge spans the Roaring Branch of the Batten Kill in Sunderland, near East Arlington. In 1971 it was seriously damaged by an overweight truck. The original floor was cut out and replaced with steel beams supported in mid-span by tall concrete pilings in the riverbed, so the author's picturesque 1966 view is impossible to retake.

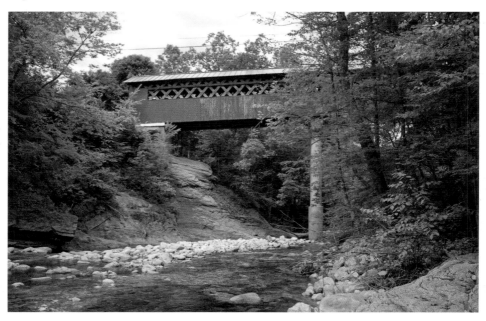

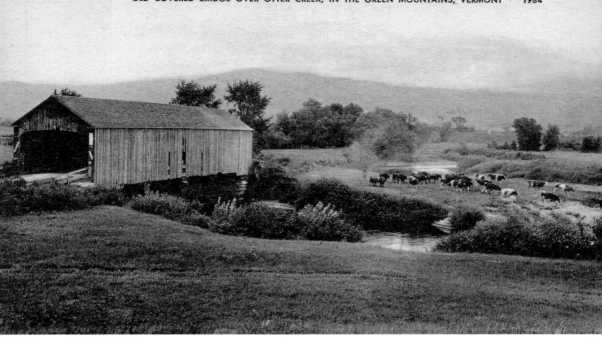

DRAMATIC LANDSCAPE DIFFERENCE: The landscape at the Billings Bridge in Rutland shows a dramatic transformation from the early twentieth century to the early twenty-first. The covered bridge spanned Otter Creek at the south end of Park Street, but it was destroyed by arson in 1952 and never replaced. The U.S. Route 4 freeway bypass now crosses Otter Creek at almost the same site.

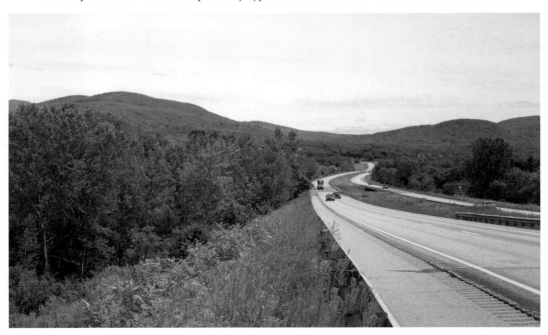

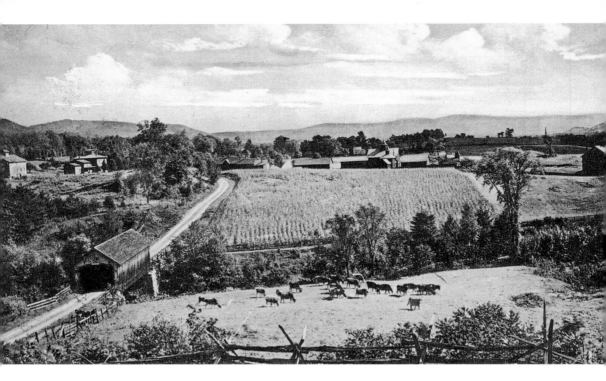

MORE CHANGE IN RUTLAND: Old '76 Bridge over East Creek in Rutland was lost to a flood in 1947 when the East Pittsford dam gave way. The view down Grove Street today shows a completely different picture. What looks like a remnant of cultivated land at background right is in fact the Rutland Country Club's golf course.

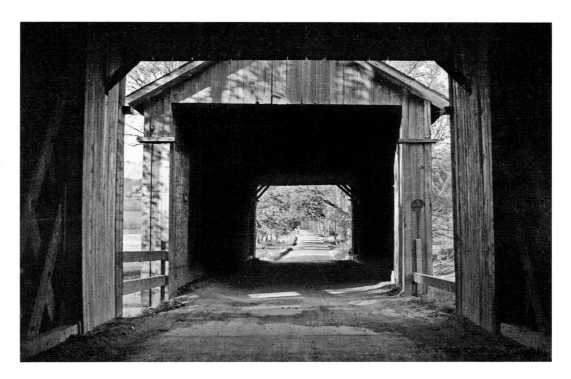

TWO COVERED BRIDGES IN A ROW: Rutland's famous Twin Bridges crossed East Creek on the road to Chittenden. One was built in 1849 but was left high and dry by a flood which cut a new channel, so another covered bridge went up just down the road in 1850. The 1947 flood ruined the Twins, although one was salvaged and converted into a shed on dry land nearby.

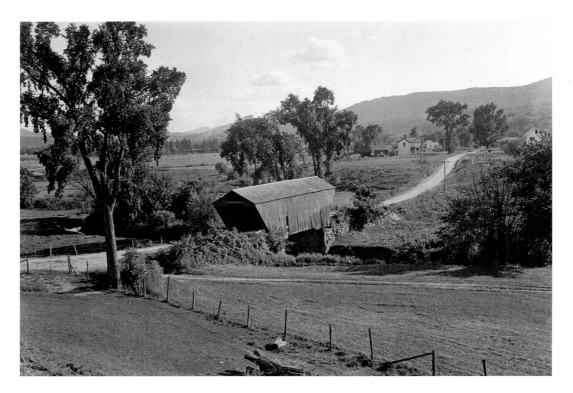

OLD RURAL LANDSCAPE: This view of Elm Street south of Pittsford dates from the 1920s, although something similar could have been taken as recently as 1965. The covered Cooley Bridge still stands in 2013, but the surrounding area is suburban. While traveling here for this retake photograph, the author had to drive around two parked trucks of landscapers mowing lawns, and one of an asphalt contractor repairing cracks in a driveway.

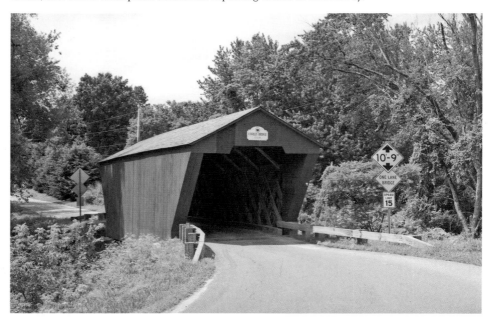

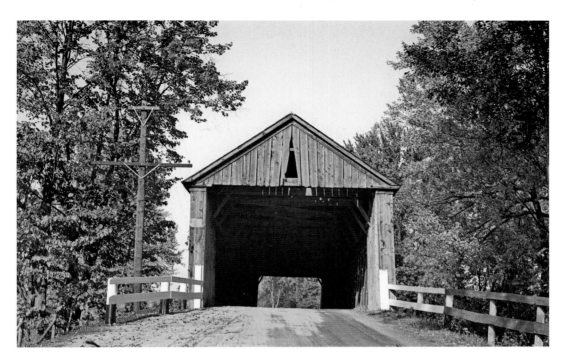

LONG-GONE BRANDON CROSSING: Dean Bridge crossed Otter Creek between Brandon and Florence, on a road which has seen a variety of names over the years, but which historically was known as Clay Street. It was destroyed by arson in 1986 and there is no trace of the old landmark today.

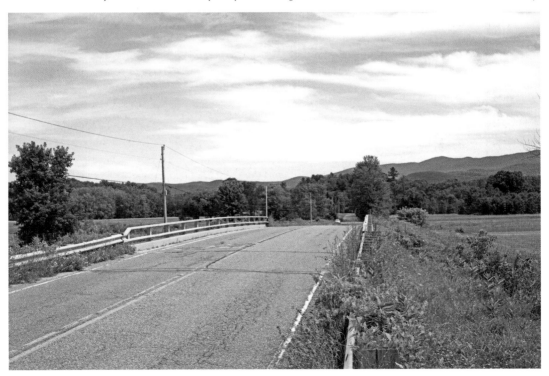

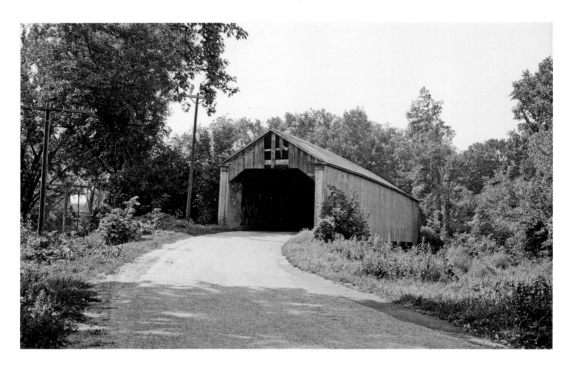

ANOTHER RECENT REPLACEMENT: Sanderson Bridge spanned Otter Creek on Pearl Street, south of the village of Brandon. The present view shows what appears to be the same bridge, much boxed in by steel guard rails and by the recent growth of trees. In fact, the 1838 covered bridge was torn down and replaced with an all-new copy in 2003, reusing only the old upper lateral bracing as a souvenir of the original bridge.

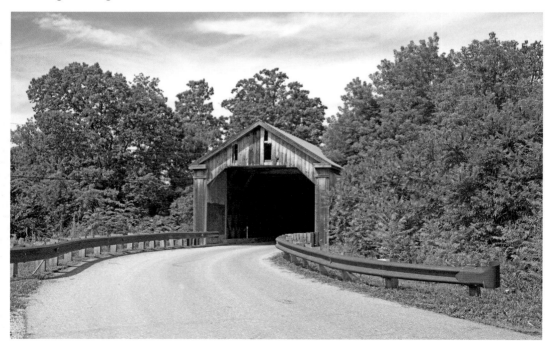

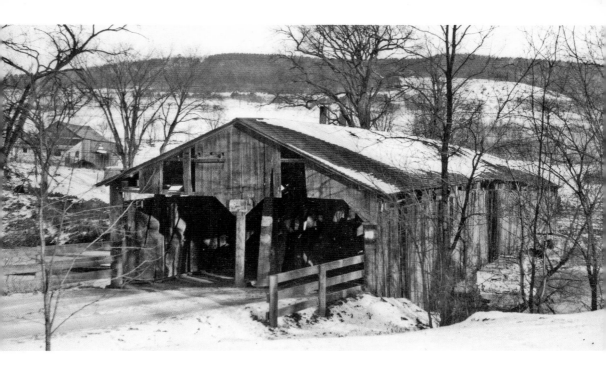

TWO-LANE COVERED BRIDGE: Pulp Mill Bridge is a "double-barrel" bridge over Otter Creek on the outskirts of Middlebury. It had structural problems from the very start, and has been rebuilt several times, although some of the trusswork is original. The photographer finds it difficult to get a good view without a forest of surrounding road signs, a common problem at covered bridges today.

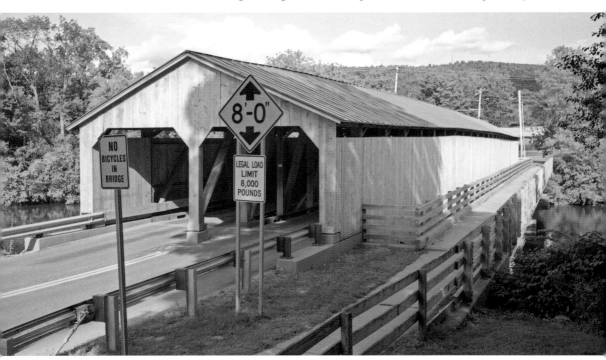

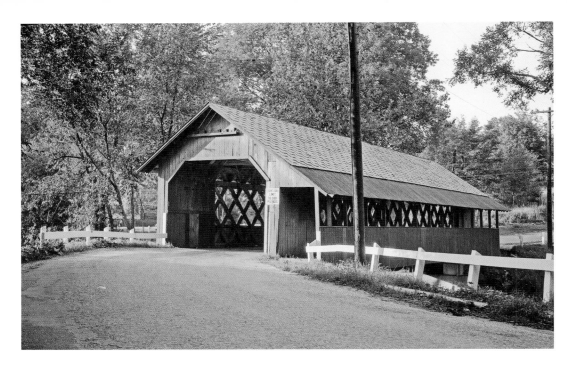

SOUTHEASTERN VERMONT LANDMARK: Brattleboro's Creamery Bridge is the most famous of the three Vermont covered bridges of this name, due to its location alongside heavily-traveled Route 9. Traffic on Guilford Street has increased tremendously, and the bridge is now honorably bypassed, the focal point of a pleasant park.

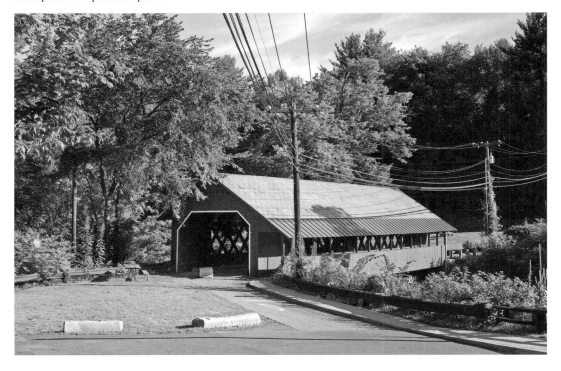

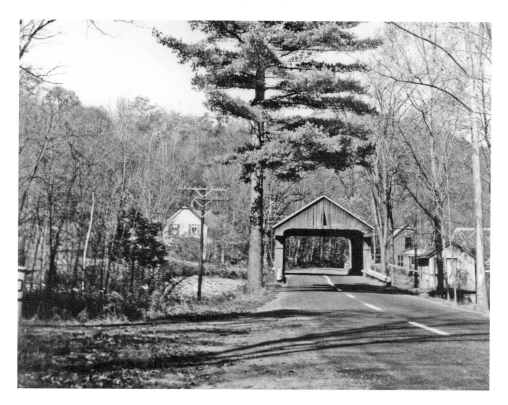

COVERED BRIDGE ON MAJOR HIGHWAY: Taft Bridge served Route 30 in Dummerston until 1952, when it was saved by moving it to Old Sturbridge Village in Massachusetts. There is no longer a settlement adjacent to the former bridge site, and the road is so busy that it is hard to imagine a covered bridge there now.

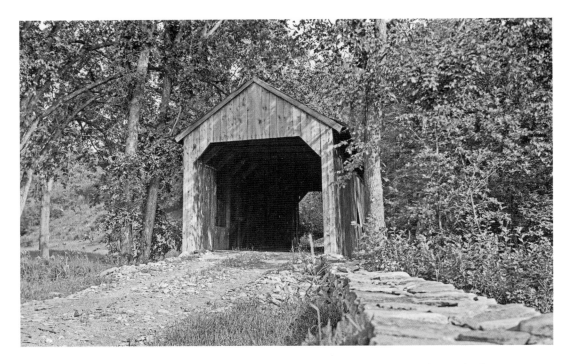

NEW SETTLEMENT BRINGS CHANGES: The district beyond the Kidder Bridge in Grafton was abandoned by the mid-twentieth century, and the covered bridge sat for several decades with little use or maintenance. The building boom starting in the late 1980s brought new settlement to the far side, and also a need for higher bridge capacity for traffic such as fire trucks or oil deliveries. Glu-lam beams were added inside in 1995.

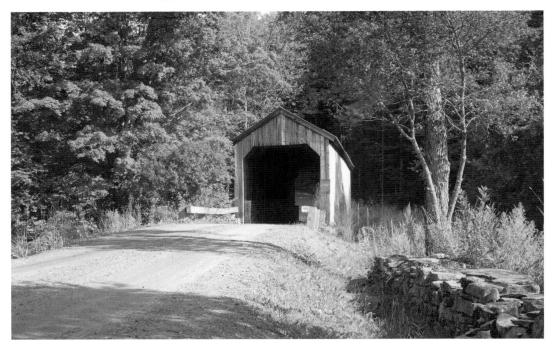

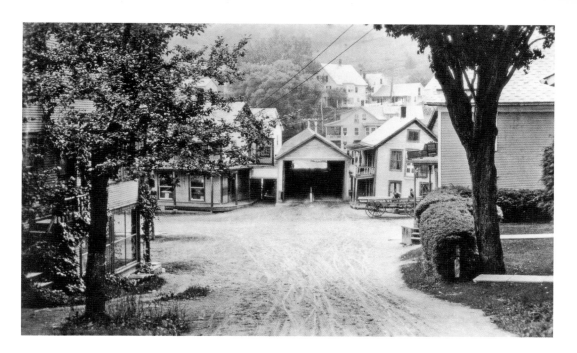

VILLAGE CENTER THINS OUT: South Londonderry's covered bridge over the West River was replaced in 1937. The village was closely built up around the bridge in all directions. A modern view from the same place shows a very attractive scene, although many of the other structures are also gone. The same economic patterns which have re-filled the countryside with habitation have thinned out many of the older settlements, not only of people but of buildings as well.

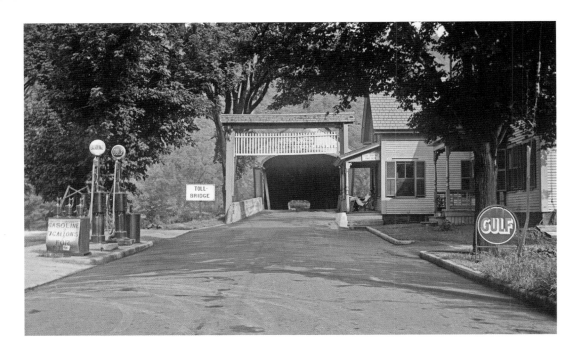

LONGEST COVERED BRIDGE IN THE U.S.A.: The Windsor-Cornish Bridge, over the Connecticut River to New Hampshire, charged toll until 1943. It was extensively rebuilt in 1989, at which time the bottom chords, or horizontal members at the bottoms of the trusses, were replaced with modern fabricated glu-lam. The job presented structural challenges specific to this bridge, and it gained accolades from some of the preservation community. However, the precedent set here has given the unfortunate impression that wholesale replacement of original structure is acceptable and indeed routine in covered bridge work. Page 19 shows another old view of this bridge.

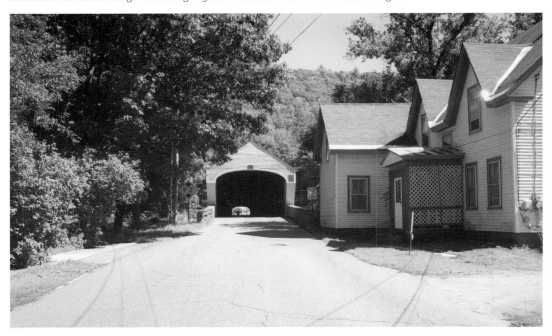

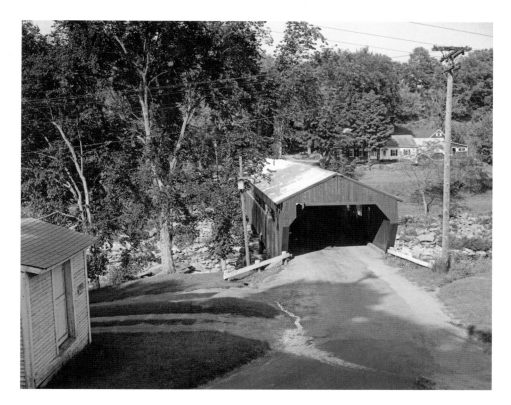

HURRICANE CAUSES DAMAGE: Taftsville Bridge has spanned Ottauquechee River near Woodstock since 1836. Long unpainted, it received a coat of bright red paint in the 1950s and has been red ever since. Hurricane Irene in 2011 caused serious damage when floating propane tanks smashed into the bridge. The south abutment was also seriously undermined, but the old bridge held. Repair work was being completed when this photograph was taken in July 2013.

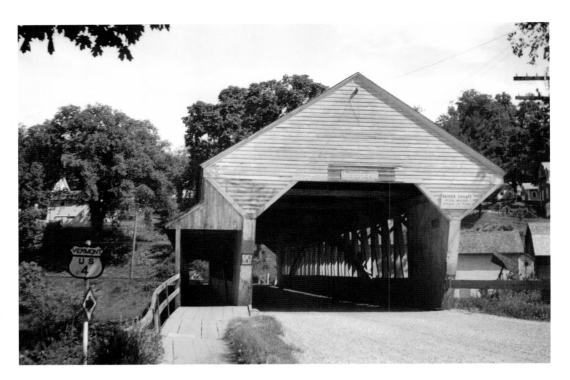

VILLAGE COVERED BRIDGE: Woodstock once had this covered bridge right on U.S. Route 4 at the west end of the village (note the route number signs). It was bypassed with a modern bridge in 1937 and stood abandoned for several years until being removed by blasting in 1944.

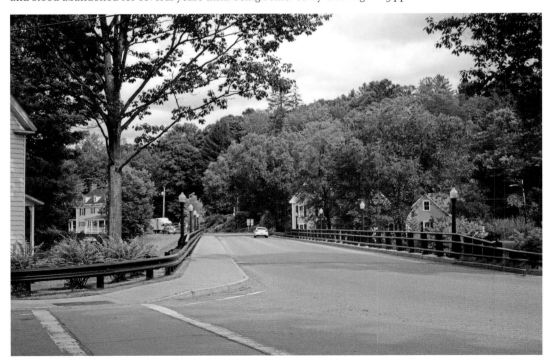

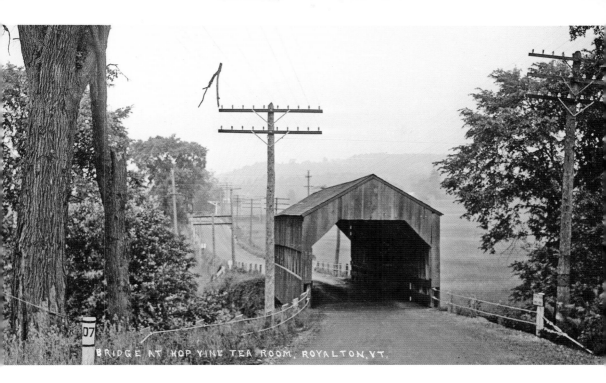

BRIDGE AT HOP VINE TEA ROOM, ROYALTON, VT.

COVERED BRIDGE ON STATE HIGHWAY: Hop Vine Bridge served Vermont Route 107 at North Royalton on the road to Bethel, and the state highway number is visible on the post at left. The covered bridge was replaced after being crushed by a falling tree in 1937 and there is no trace of it left.

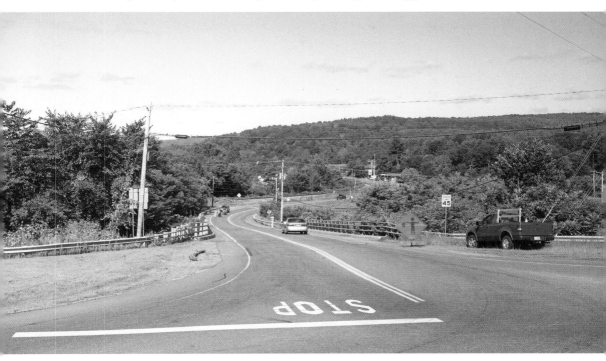

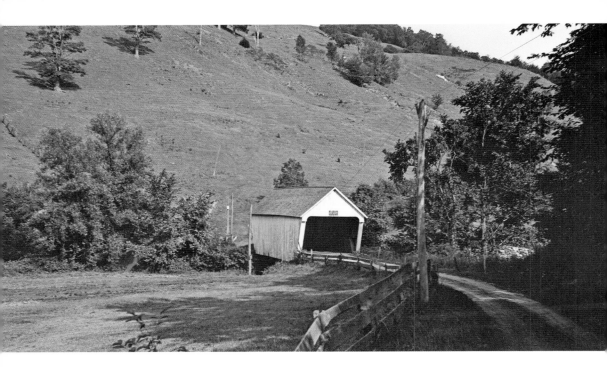

LANDSCAPE CHANGES, BRIDGE STILL THERE:  Gifford Bridge near East Randolph, Vermont shows the transformation of the New England landscape. The 1920s view by Daniel Wheeler shows hillside pasture. By the time of Herbert Richter's 1955 photograph, the pasture was a timber plantation. A close look reveals that by then the covered bridge had some assistance from steel beams inside, although the original structure was still intact and functional.

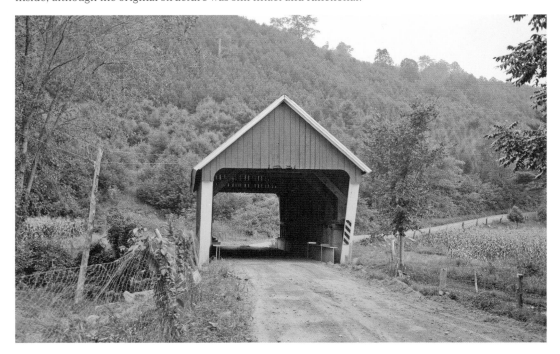

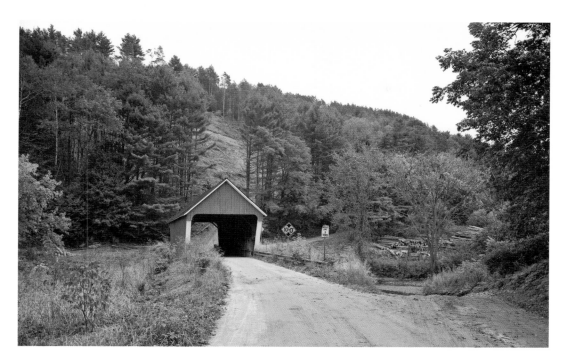

BRIDGE IS NOW REBUILT: The author's 2009 photo of Gifford Bridge shows a timber harvest taking place, but the covered bridge still looked much as it had in 1955. By 2013 it had been rebuilt. The steel beams were replaced with glu-lam, and the old floor system was cut out and discarded. The deck is supported completely by the glu-lam beams, and the old trusses carry only their own weight.

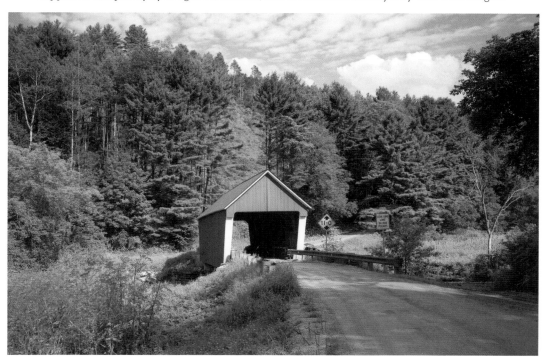

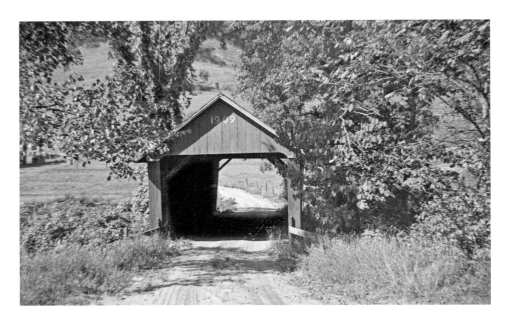

OLD NEW ENGLAND LANDSCAPE: Nearby is the Braley or Upper Bridge, which like the Gifford Bridge crosses the Second Branch of White River. Richard Sanders Allen's 1940s view shows it in good condition. In the author's 1973 photo it is more ragged, but the scene is otherwise little changed from the early days.

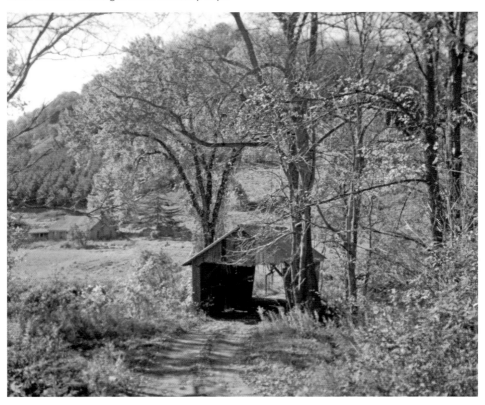

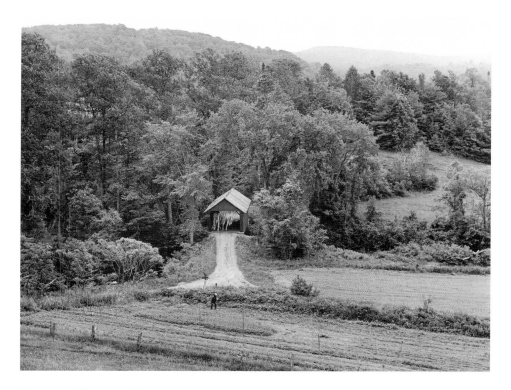

ANOTHER REBUILT BRIDGE: A 1982 look at Braley Bridge shows a makeshift attempt to prevent rain water from blowing in at the portal. But decay had already set in. In 2013, the deck is completely supported by modern beams, and the much rebuilt trusswork is now decorative, carrying only its own weight. The trusses have also been raised in order to sneak in some extra clearance inside.

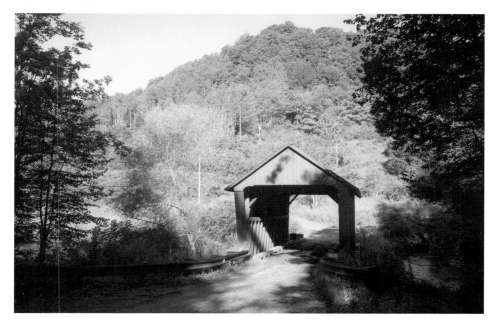

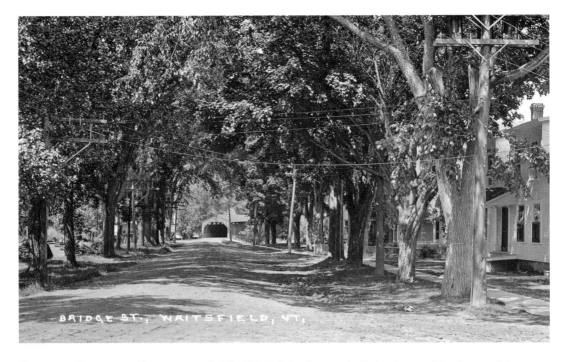

COVERED BRIDGE IN TOWN: Waitsfield's Old Arch Bridge was built in 1833, making it one of the oldest covered bridges in New England. A separate covered sidewalk was added in 1940, but the extra dead load has since caused some structural problems. The portal received its present appearance after repairs in 1973. The bridge carries heavy traffic in the heart of the busy resort village of Waitsfield, which may necessitate further repairs.

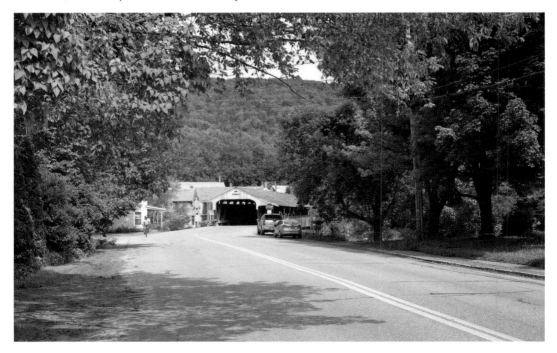

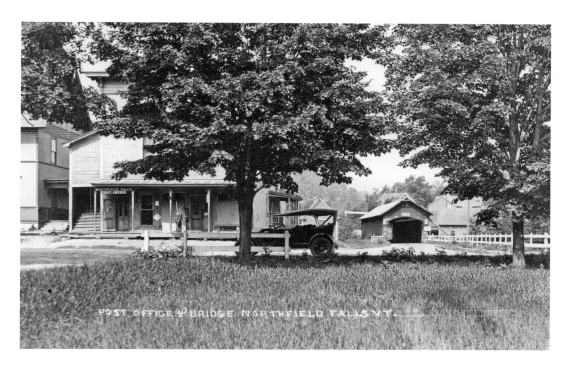

COVERED BRIDGES EVERYWHERE: In 2013, Northfield Falls still has a covered bridge over Dog River right downtown, and if you look beyond it you can just make out another covered bridge on Cox Brook (hidden in the early photo). There is a third, also over Cox Brook, just around a bend on the same road, while a fourth spans Dog River on a side street to the south—the most concentrated collection of covered bridges anywhere.

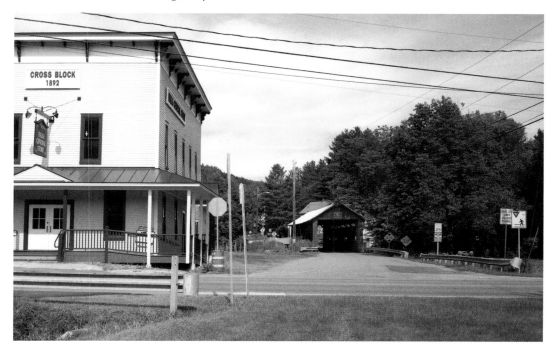

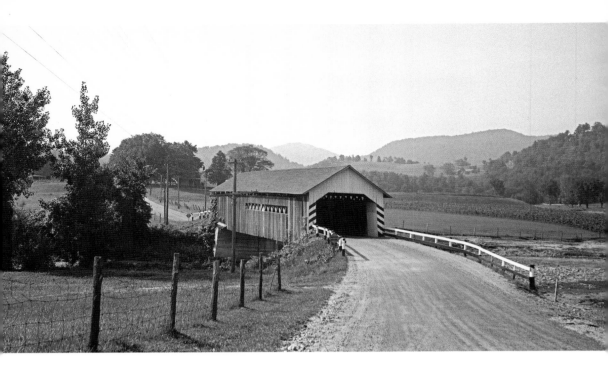

DISTINCTIVE SETTING: Towers Bridge, over Huntington River in the south part of Richmond, was demolished in 1948. In the early twenty-first century, the site remains attractive and readily recognizable because of the profile of the nearby hills, but it is in the outer suburbs of Burlington, and sees so much traffic that it is hard to imagine a covered bridge here.

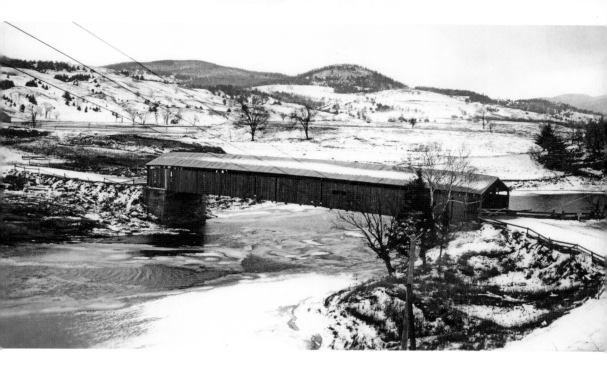

SUPERHIGHWAY OVER OLD BRIDGE SITE: Checkered House Bridge crossed the Winooski River west of Richmond on U.S. Route 2. The 1927 flood damaged its approaches, and it was replaced in 1929 with a steel truss which has since been widened, but is still in service on the realigned road. The southbound lanes of Interstate 89 were later built high over the Winooski directly on the site of the old covered bridge. The new photo shows both of the present bridges, and was taken in 2013 from a popular fishing spot upstream from the old view.

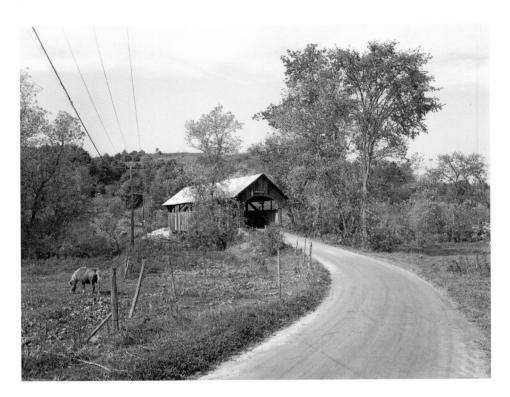

TREES CHANGE, BRIDGE STILL THERE: Coburn Bridge near East Montpelier had its floor replaced with steel beams in 1973, but they were mostly hidden, and the author's 1983 view still showed a classic New England rural landscape. The bridge itself still looks the same, but the loss of the old elm trees and the other changes in the forest surroundings make for a much different photograph.

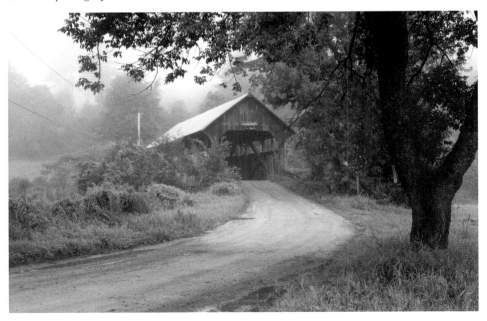

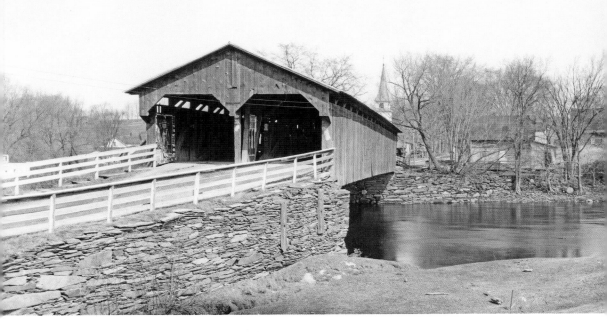

ANOTHER TWO-LANE COVERED BRIDGE: This "double-barrel" covered bridge spanned the Lamoille River at Fairfax until it was destroyed in the great flood of 1927. The church building in the background has been vastly expanded as the Steeple Market, and the steeple alone remains as a landmark from the old scene. Fairfax still has a covered bridge over Mill Brook on a nearby side street, but it is not visible from this location.

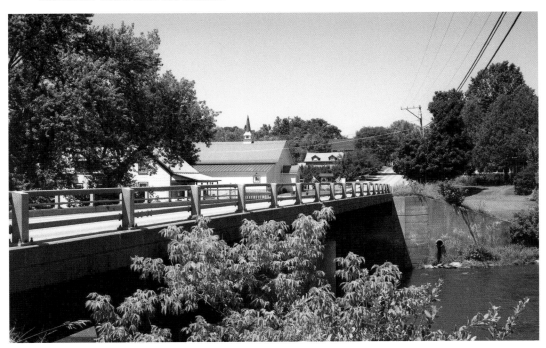

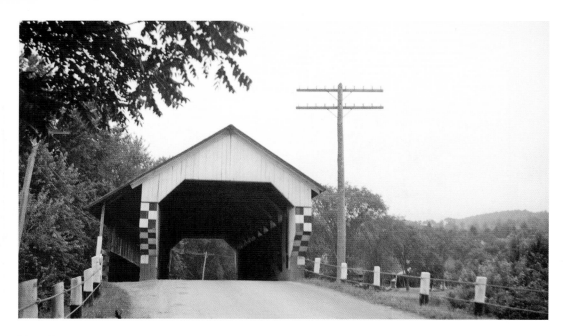

TWO BRIDGES IN CAMBRIDGE: Two covered bridges once served State Highway 15 just east of Cambridge. The bridge in the foreground crossed Seymour River, while the other, just visible at background right, crossed Lamoille River. In the 1950s there was a brief engineering fad for moving rivers as a solution to bridge problems. The Seymour was re-routed through the field at right, and Route 15 no longer needs a bridge here. The new channel cut the Gates Farm in two, so the covered bridge was moved aside to serve the farm (off camera position to right). Meanwhile the covered bridge over the Lamoille was moved to the Shelburne Museum and preserved.

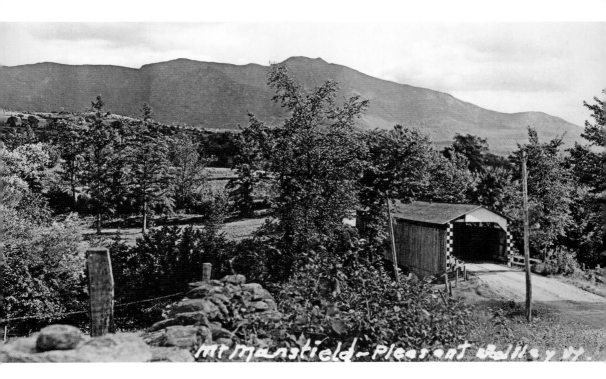

OLD LANDSCAPE LONG GONE: Safford Bridge once spanned Seymour River in the Pleasant Valley section of Cambridge. The lovely contours of Mount Mansfield still dominate the view, but the covered bridge is long gone and forgotten. The site from which the old photo was taken became part of an electric substation later in the twentieth century.

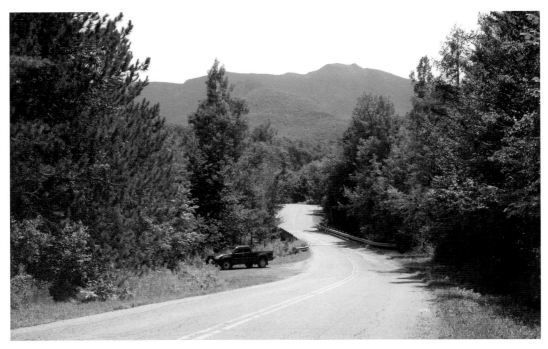

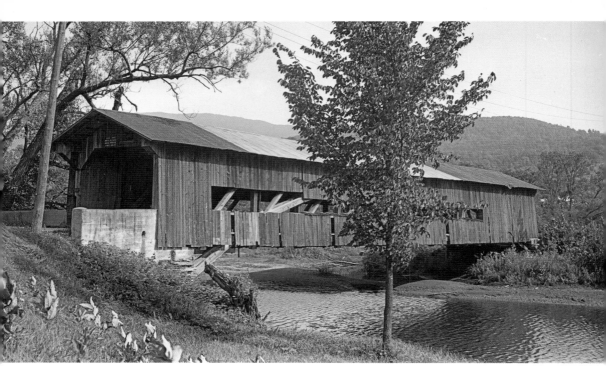

STOWE AREA LANDMARK: Henry Gibson's 1948 photograph shows the covered bridge over Waterbury River at Moscow, in the southern part of the town of Stowe. The bridge was replaced two years afterwards, but the site is still recognizable despite the heavy recreational development that has taken place in Stowe since then.

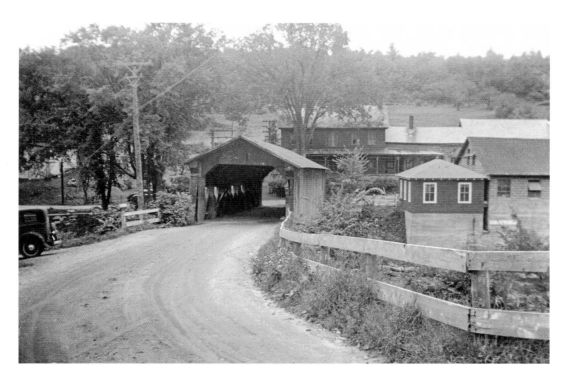

LITTLE CHANGE AT LOWER VILLAGE: Stowe's Lower Village Bridge was also known as the Stoware Bridge, from the company that owned the adjacent factory. It was replaced in 1940, but except for the bridge, the neighborhood has changed surprisingly little since Richard Sanders Allen's photograph was taken in the late 1930s.

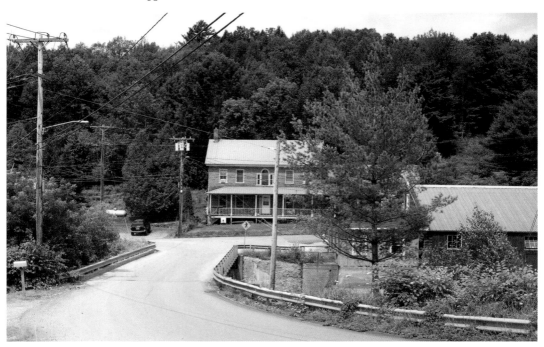

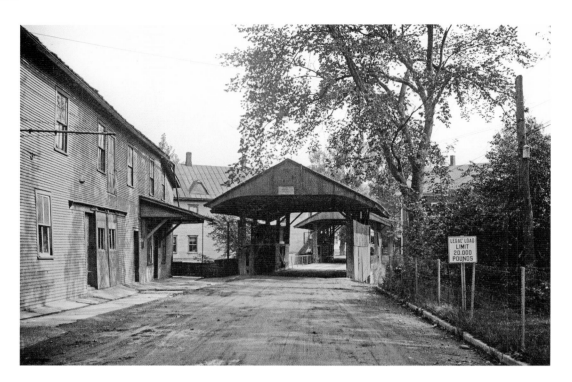

JOHNSON TWIN BRIDGES: Twin covered bridges crossed Gihon River on Pearl Street in downtown Johnson, using a tiny island as a center pier. The state was proud of the clean lines of the one-span concrete successor when it went up in 1937. Nothing much is left of the island in 2013.

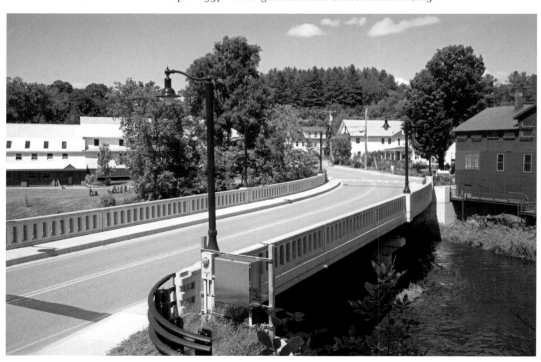

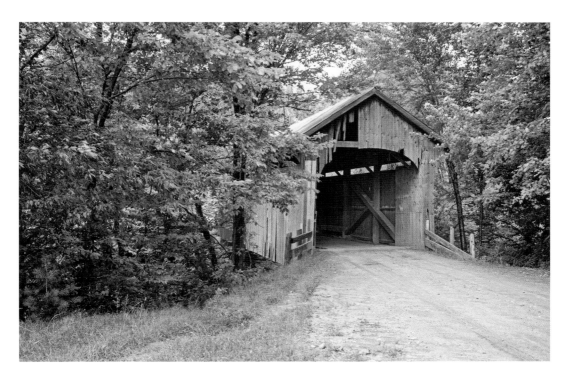

A PLACE TIME ALMOST FORGOT: Steel beams replaced the old floor system in the Lumber Mill Bridge of Belvidere around 1970, but the original trusses were preserved, and the quiet site is among the least changed by time of any of Vermont's covered bridges.

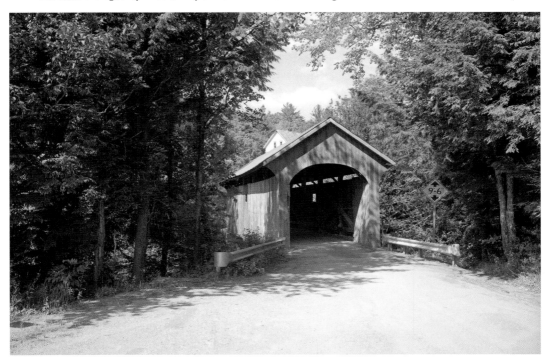

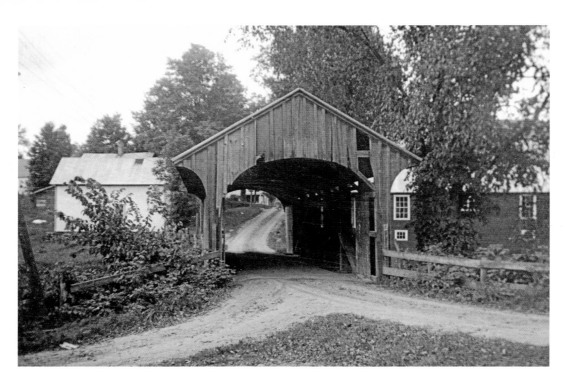

VILLAGE STREET SCENE:  Waterville Village Bridge looks much the same today as in Richard Sanders Allen's old view taken around 1940. The setting in a small village, instead of out in the country, offers extra interest to this attractive but otherwise modest bridge.

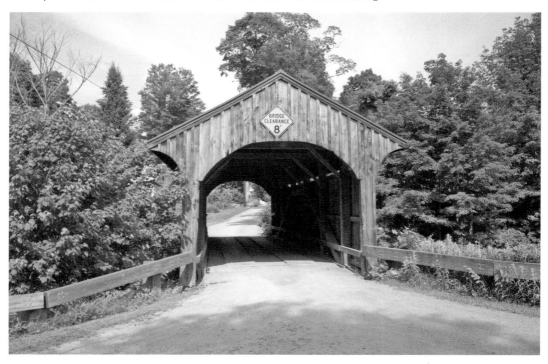

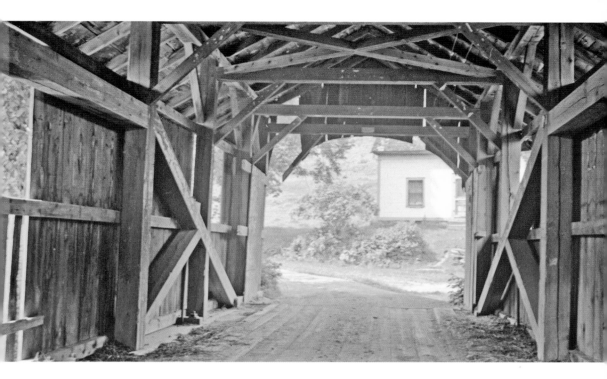

INSIDE THE COVERED BRIDGE: An interior view of the Waterville Village Bridge shows the stout queenpost trusses, little altered by time, although they now carry only their own weight. Steel beams were hidden under the floor around 1970 to carry the traffic.

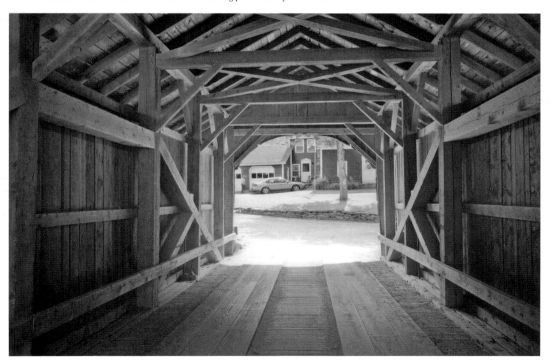

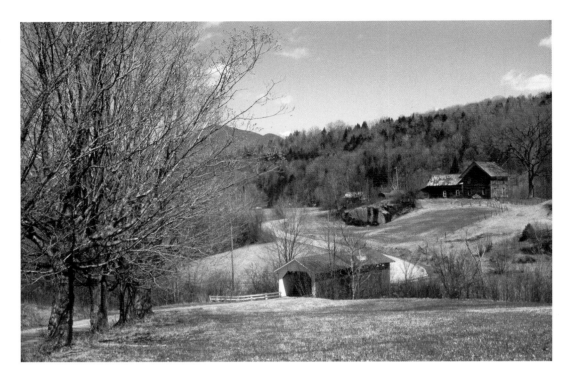

COMPLETELY CHANGED BY TIME: Montgomery was known as Vermont's top covered bridge town, and until recently it had six of them. The most attractive was surely the Hectorville Bridge on the South Branch of Trout River. The author's 1974 photograph shows a landscape little changed since the 1930s. But the bridge was bypassed in the 1980s, and later moved away into storage over security concerns. All of the other nineteenth-century buildings in the area have also disappeared, leaving the distant mountains as the only recognizable landmark.

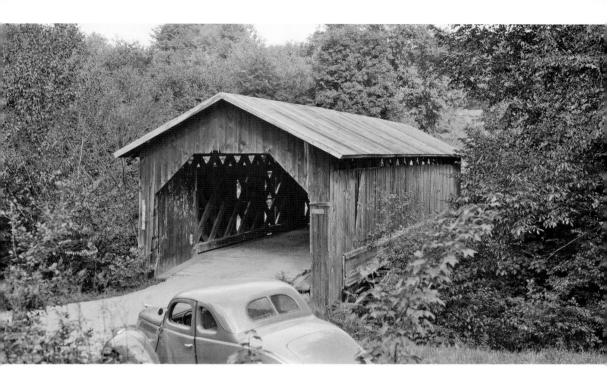

MUCH REBUILT BUT STILL USED: Just downstream from Hectorville, the Hutchins Bridge still crosses the South Branch, although about half of the original timber was replaced during twenty-first century repairs. A natural ledge outcrop once formed the eastern abutment, but it was encased in concrete in the late 1970s and is no longer visible.

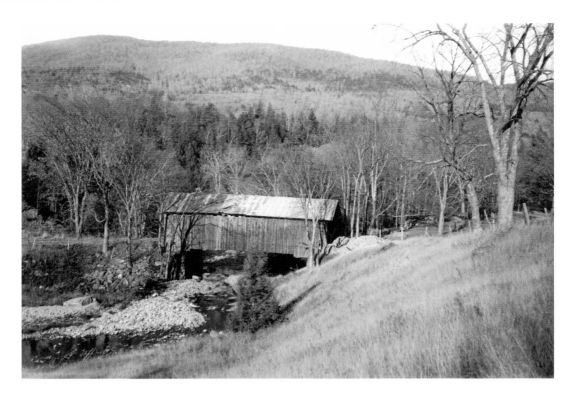

UP ON THE WEST HILL: Montgomery's Creamery Bridge still stands on the West Hill. Richard Sanders Allen's 1940s view could still have been taken as recently as the 1970s, but the bridge is now hidden in the forest. It retains most of its original structure, although the strong scent of the southern yellow pine used during repairs altered the aesthetic experience for visitors in 2013.

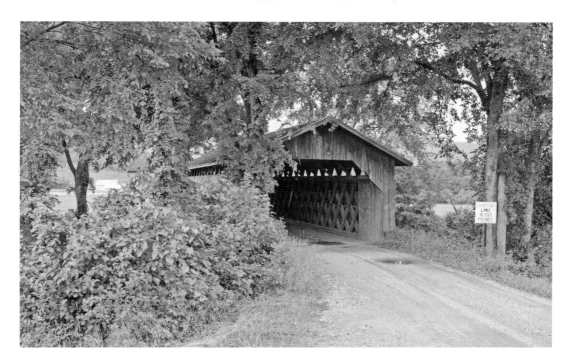

BRIDGE SOON TO BE REPLACED: Longley Bridge spans Trout River west of Montgomery on the road to East Enosburg. This part of town is far enough from the ski development at Jay Peak to be little affected by suburbanization, but the large agricultural equipment in use in the area requires a new bridge. Longley Bridge will be torn down and replaced with a modern replica.

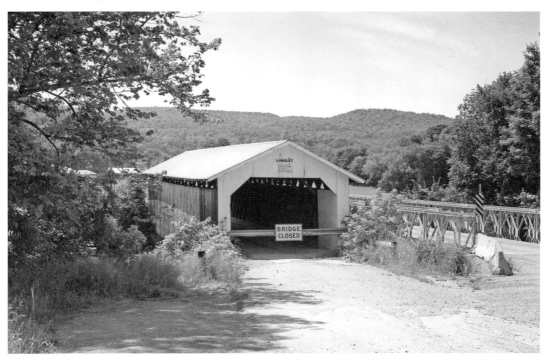

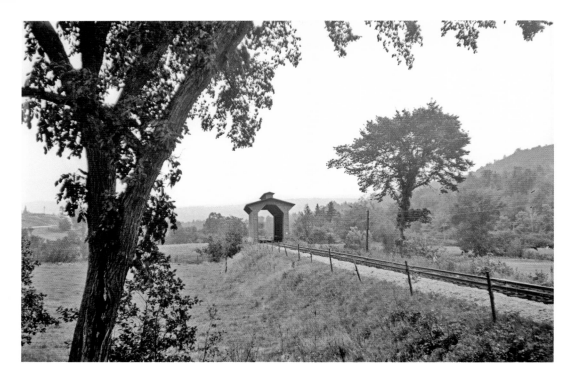

RAILROAD BRIDGE WITH CUPOLA: Fisher Bridge, over the Lamoille River near Wolcott, is one of the very few covered bridges which really did have a cupola. It was built in 1908 for the St. Johnsbury and Lake Champlain Railroad, and the cupola vented smoke from steam engines. Two other covered bridges on this line were torn down in the late 1960s. Fisher Bridge was preserved by special arrangement with the railroad, although steel beams were inserted to carry new heavier live loads. In retrospect all of the covered bridges might as well have been preserved, because the railroad only operated for a few more years.

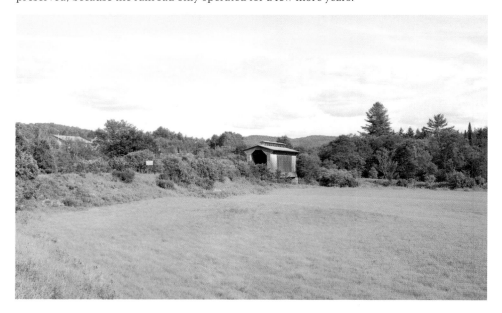

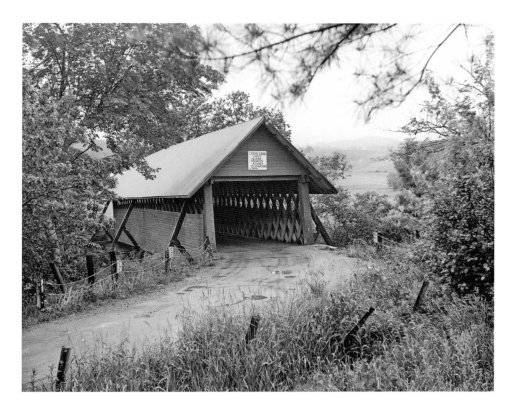

NORTHERN VERMONT CROSSING:  The Upper Bridge over the Missisquoi River near North Troy still carries traffic, but it is too small for large agricultural equipment, which must use a ford just upstream. The most obvious visual difference between the author's old and new photos is that the 1930s-era post and cable road fences have given way to metal guard rails.

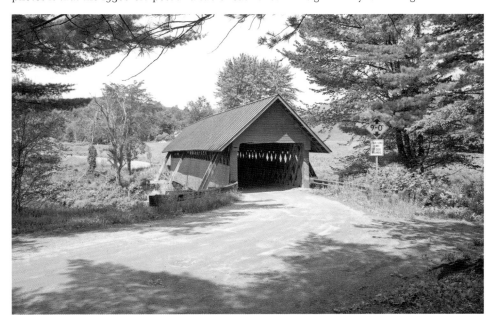

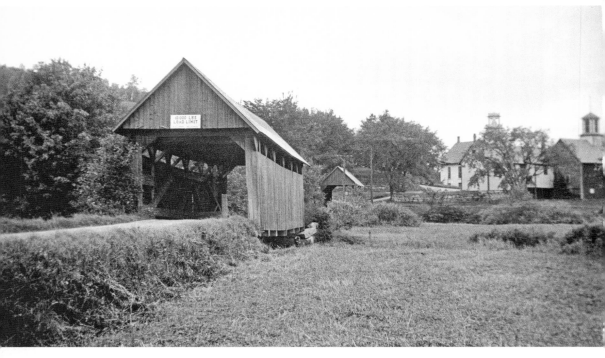

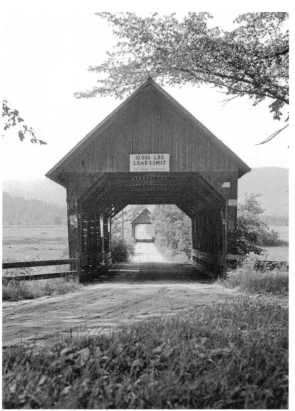

**MORE TWIN BRIDGES:**
East Charleston had a famous set of twin covered bridges, over meandering channels of the Clyde River in a wide flood plain. One of the crossings became a modern bridge, while the other is only a culvert. The surroundings, however, are still very much agricultural.

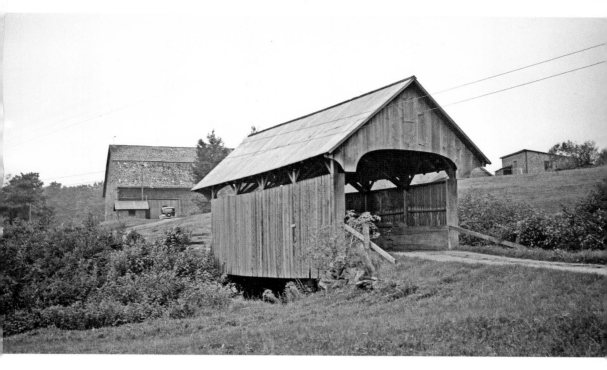

**BRIDGE REPLACED BY CULVERT:** The covered bridge at Morgan crossed the outlet of Mud Pond about a half-mile north of the village. It was said to have been the highest covered bridge in Vermont above sea level, variously reported as 1,450 or 1,456 feet. It was replaced in 1958 with a culvert, the road was later widened, and there are no traces. The barn in the old photograph was some distance to the right of the modern shed.

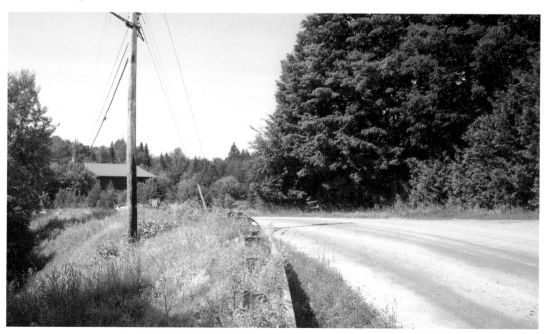

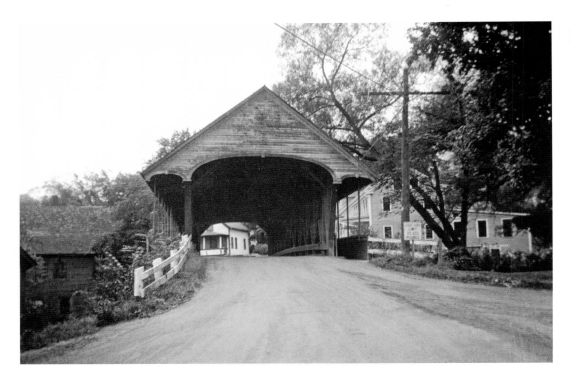

VILLAGE BRIDGE OF YESTERYEAR: Barnet is still a lovely village, well hidden from nearby Interstate 91. The covered bridge over Stevens River at Monument Square was removed in 1948. The graceful arched portal extended outwards to the wide eaves, a style common in covered bridges of northeastern Vermont and adjacent parts of New Hampshire.

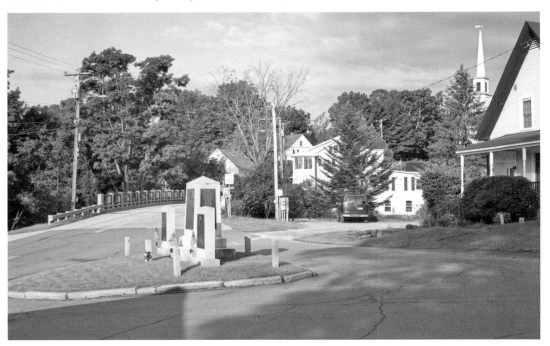

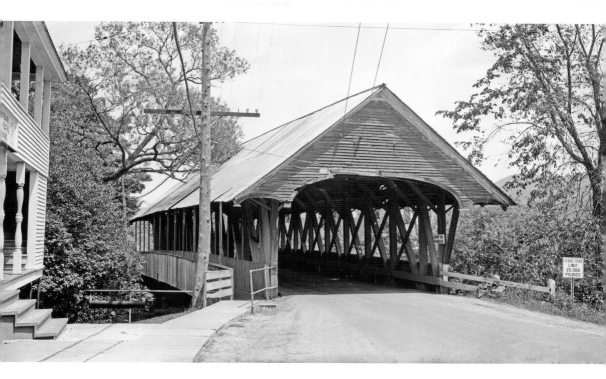

THE VILLAGE WITHOUT ITS BRIDGE: Henry Gibson's 1948 view of Barnet from the other end shows a village relatively little changed by time except, now, for the loss of its old covered bridge. U.S. Route 5 is just east of the bridge site, but carries little traffic in 2013.

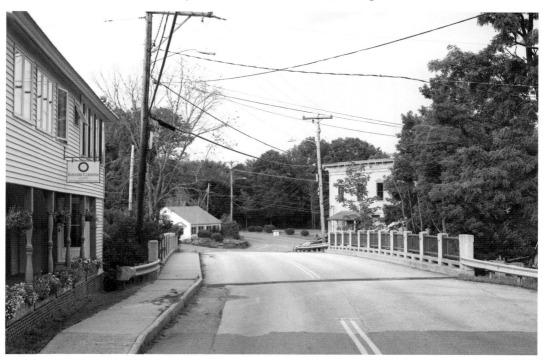

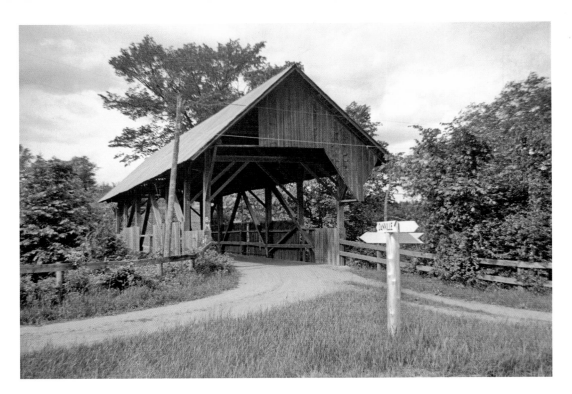

QUIET COUNTRY SETTING: Greenbank's Hollow Bridge, in the south part of Danville, developed a broken bottom chord, the horizontal member at the bottom of the truss. This is an expensive repair, and often results in the replacement of the entire bridge. Here instead it was reinforced inside with steel I-beams, but they were removed during a 2002 restoration, and the bridge once again looks much as it did in the distant past.

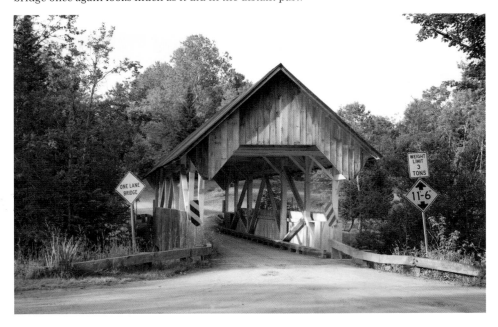

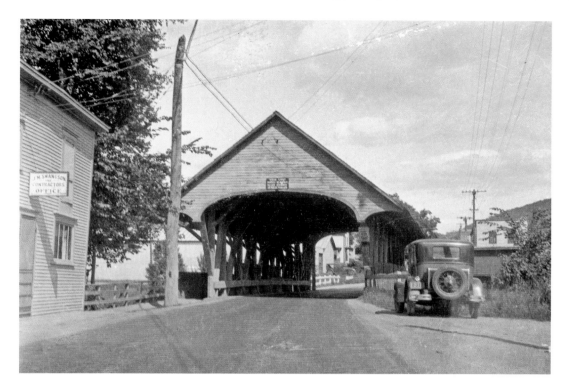

BUSY URBAN SETTING: St. Johnsbury once had over a dozen covered bridges, many of them of the Paddleford truss construction. Famous builder Peter Paddleford lived nearby in Littleton, New Hampshire, and may have worked in St. Johnsbury, but the local history is little known. This example crossed Moose River on Portland Street in the east end, but it was torn down in 1932 and is now long forgotten.

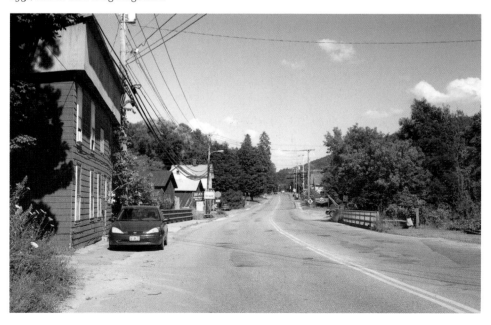

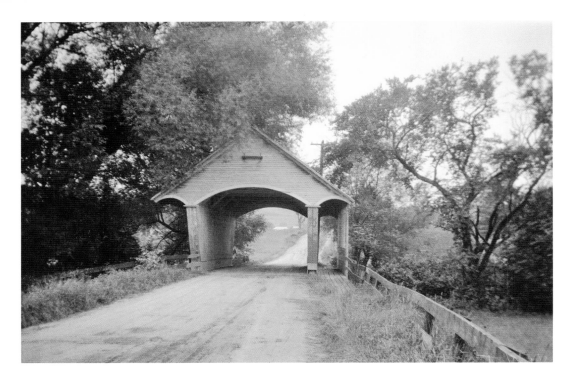

BYPASSED BRIDGE PRESERVED: Schoolhouse Bridge, at the north edge of the village of Lyndon, was bypassed in the early 1970s when South Wheelock Road was relocated. The original arched portals had later been sawed square for higher clearance, but after the bypass they were put back to something like the profile that we see in the early photo. However, the graceful arch style of an old covered bridge portal is among the most difficult details for restorationists to reproduce exactly.

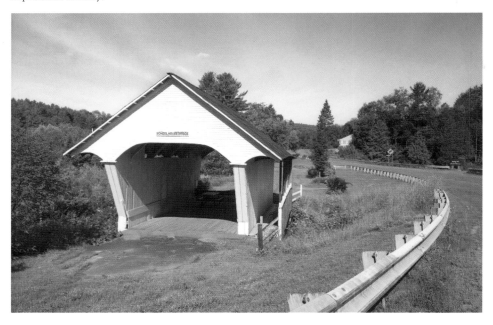

# NEW HAMPSHIRE

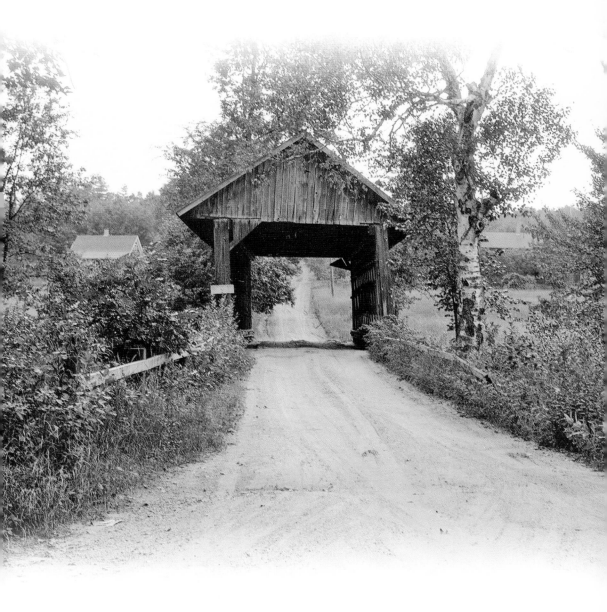

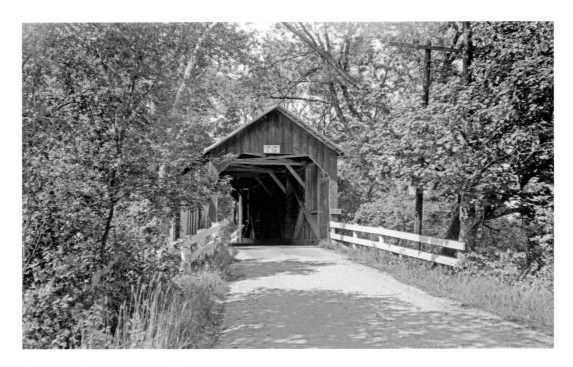

COVERED BRIDGE IN THE SUBURBS: Swanzey has been mostly suburban since the 1970s, and officials have worked diligently to keep their four covered bridges open, in the face of increasingly heavy commuter use. Carlton Bridge of East Swanzey once served a quiet wooded road. It is out in the open and sees frequent traffic in 2013. Its bottom chord timbers have been replaced with glu-lam, although it is still a functional timber truss.

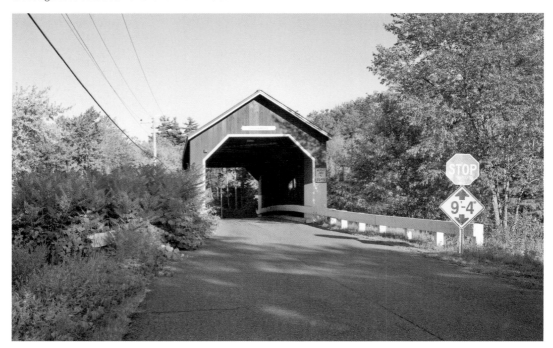

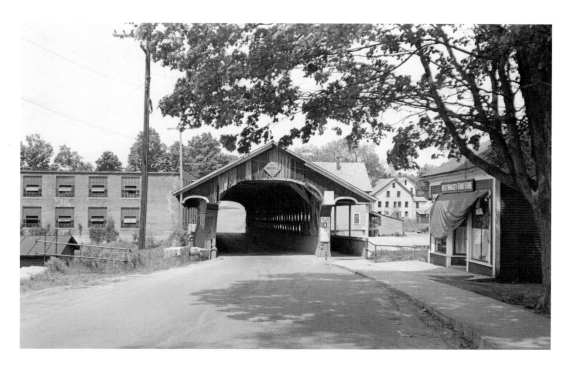

COVERED BRIDGE IN INDUSTRIAL SETTING: Thompson Bridge stands in a curiously urban location at the heart of the old industrial village of West Swanzey, an important cultural reminder that the covered bridges of yesteryear were not always in rural locations. As the countryside has become more populated, the older urban centers have become less dense, and Thompson Bridge stands more in the open than it did when the old photograph was taken.

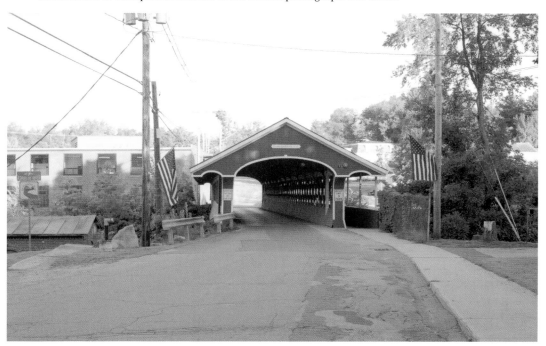

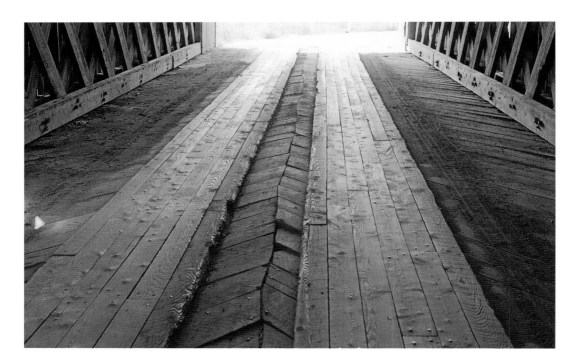

LOSS OF DETAIL: When covered bridges are updated for modern use, they often lose some of their individuality. The older floor planks of Sawyer's Crossing Bridge in Swanzey have given way to something smoother and more generic, probably a necessity since the bridge has come to carry very heavy traffic.

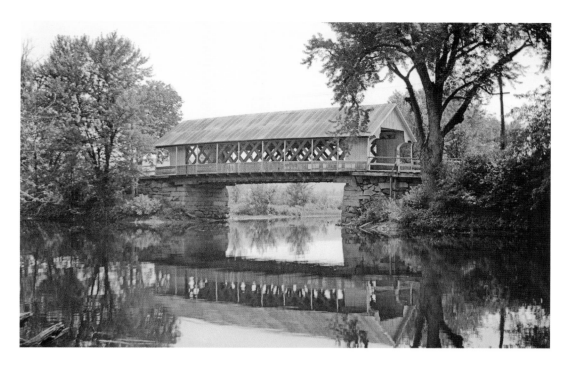

NO TRACE OF COVERED BRIDGE: Richard Sanders Allen's photo of the Mirey Brook Bridge on Route 10 just south of Winchester was taken from the west bank of the Ashuelot River. A view from the same place in 2013 shows no trace of the covered bridge, although one of similar design may still be found nearby at Ashuelot Upper Village.

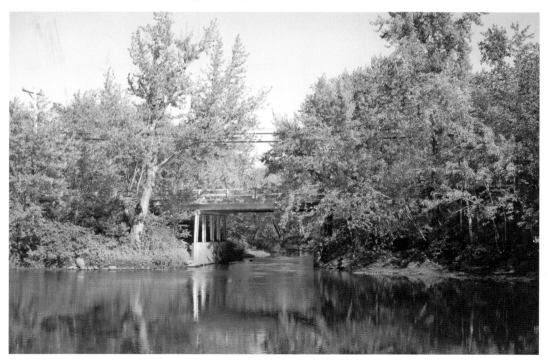

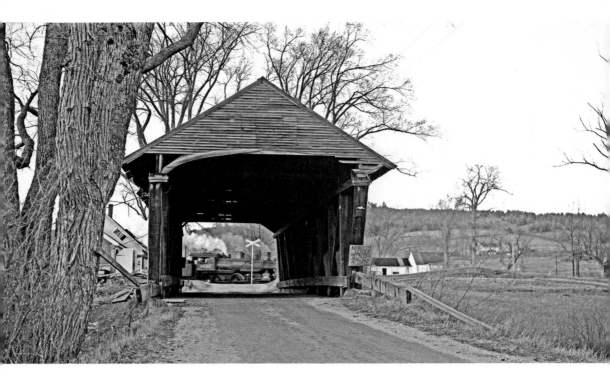

RAILROAD GONE, BRIDGE STILL THERE: Bement Bridge in Bradford looks much the same as it did when Henry Gibson's view was taken in 1949, but of course the steam engine no longer crosses in the background, and the railroad tracks themselves are gone.

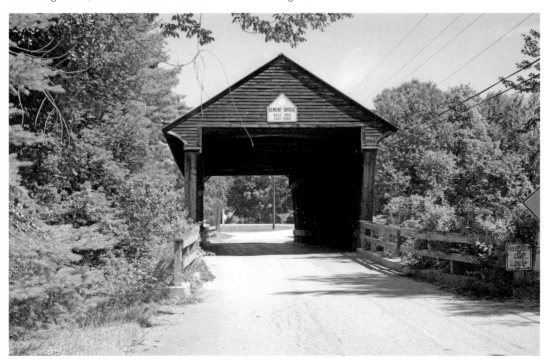

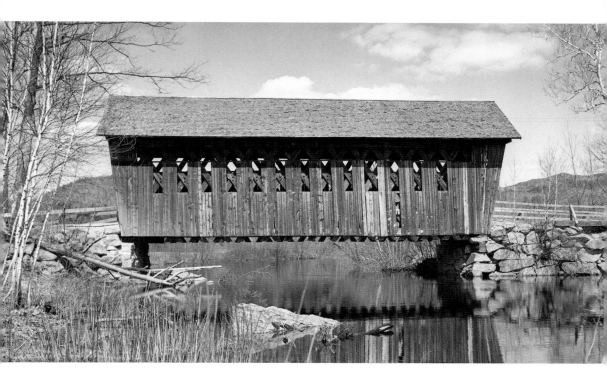

SAVED FROM NEGLECT: Cilleyville Bridge in Andover sat abandoned for many years after being bypassed in 1959. It was restored in 2004 by master framer Tim Andrews, who is well known for saving as much original structure as possible. Here Andrews found so much serious decay that even he had to replace nearly half the timber. The photo on page 71 is an old view of this bridge.

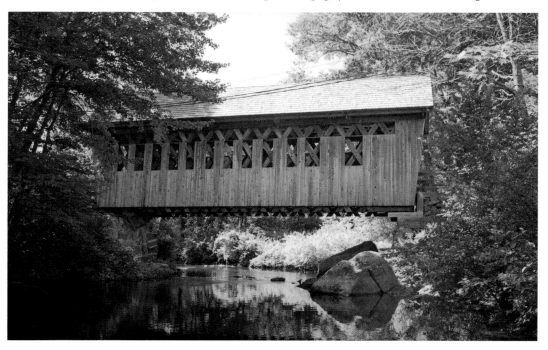

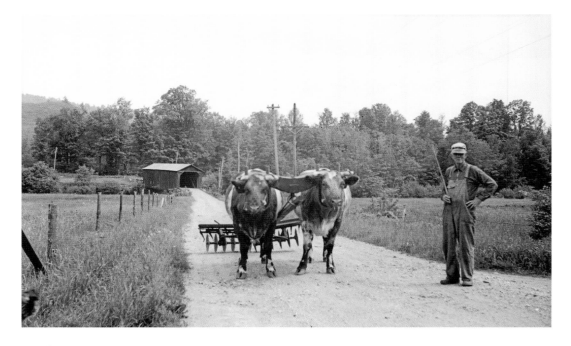

FOR SNOWMOBILES NOW:  McDermott Bridge still spans Cold River along a quiet road in Langdon, but it was bypassed in 1964 and came to serve as a snowmobile route. When covered bridges needed strengthening in the old days, they often received supplemental arches laminated from plank. McDermott Bridge once had an interesting and very early example of such arch reinforcement, but the arches were removed during recent repairs.

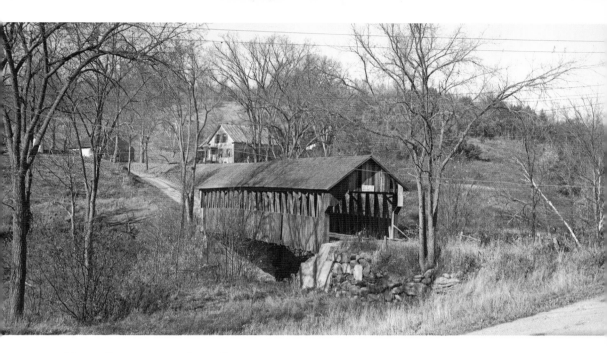

MUCH REBUILT, BUT STILL RURAL: Meriden Bridge in Plainfield seems at first glance to have changed little since the days of Raymond Brainerd's 1947 view, except that it has become harder for the photographer to avoid the utility wires. But only the side trusses of the bridge are original. The old floor system was replaced with steel beams in 1963, and the roof frame was entirely redone after being crushed by heavy snow in 1977. The wood shingle roof and the timber guard rails add an artistic touch.

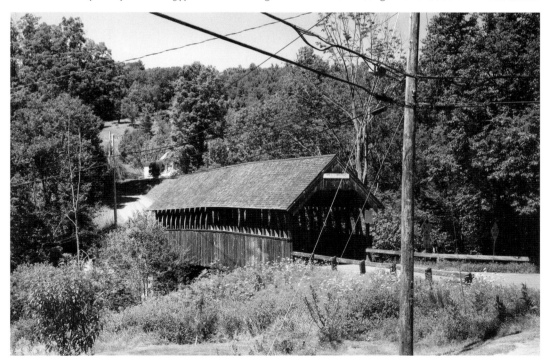

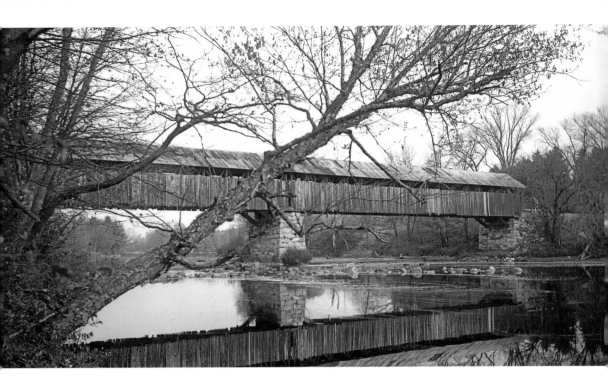

REPAIRS IN PROGRESS: Blair Bridge crosses the Pemigewasset River in Campton, just a quarter-mile east of an interchange on busy Interstate 93. The famous timber framer Milton Graton did repair work on this bridge in 1977, and his son Arnold was making some more repairs when our photo was taken in 2013.

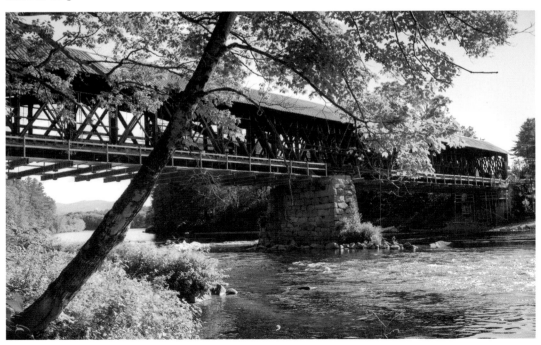

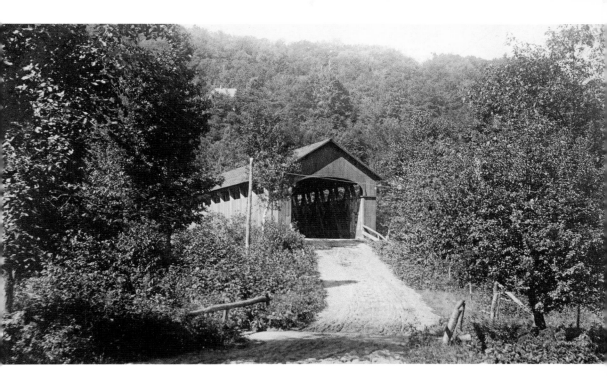

COVERED BRIDGE GIVES WAY TO ARCH: Fairview Bridge over the Pemigewasset River near North Woodstock, New Hampshire was sheltered in the woods in the early twentieth century photo. Later, the surroundings were cleared out and the side boarding was lowered to give a clearer view of oncoming traffic. But there is no trace of the covered bridge left, although the present steel tied arch bridge is impressive.

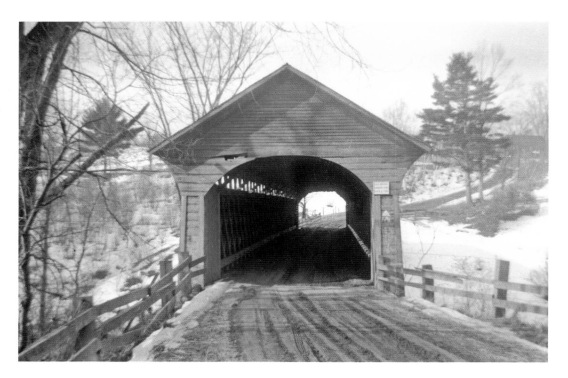

OLD NEW ENGLAND SETTING: Edgell Bridge in Lyme spans Clay Brook near its mouth on the Connecticut River. It has seen its share of repairs over the years, but it is a rare quiet site. Except for the steel guard rails, Edgell Bridge almost seems like a New England covered bridge of the 1960s.

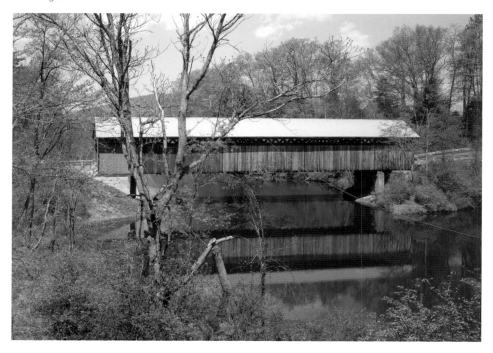

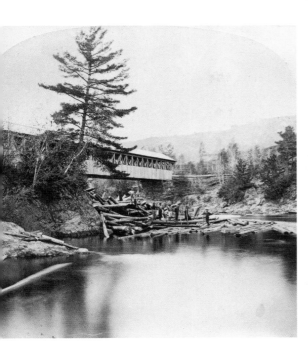

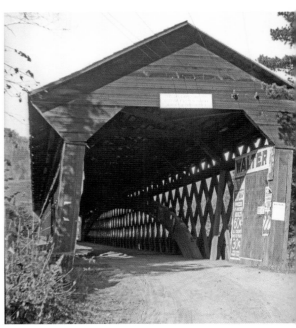

BRIDGE OVER THE CONNECTICUT RIVER: The antique view at upper left shows a covered bridge over the Connecticut River between North Monroe, New Hampshire and Barnet, Vermont, which was lost to a flood in 1866. At right is its 1877 replacement, as it looked to famed engineer John W. Storrs in 1922. This covered bridge gave way to the present steel truss in 1938.

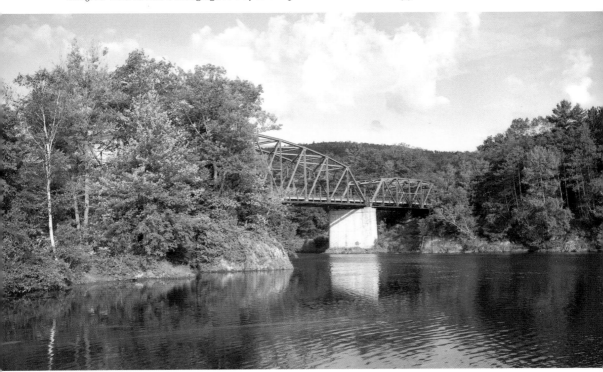

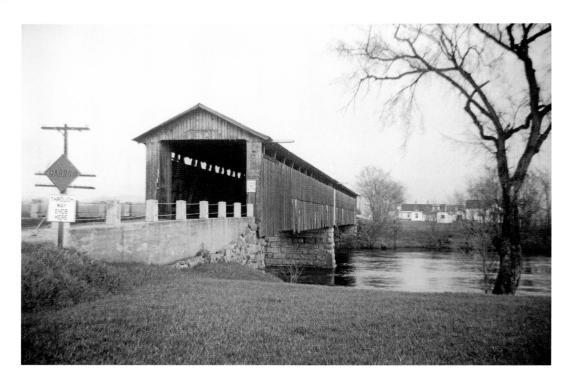

ANOTHER CONNECTICUT RIVER BRIDGE: Bridge Street Bridge crossed the Connecticut River on busy U.S. Route 2 just west of Lancaster. The steel truss which replaced it in 1950 is still in service, but it has come to look like an anachronism. The Vermont state line is the west riverbank, so bridges over the Connecticut River are mostly in New Hampshire.

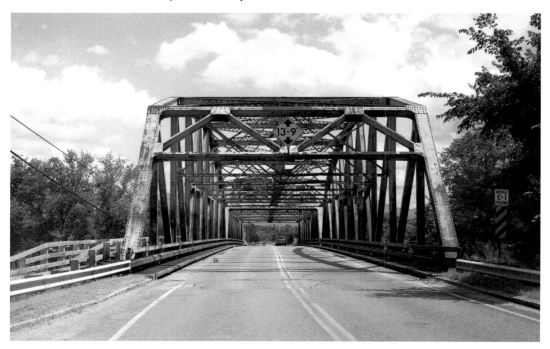

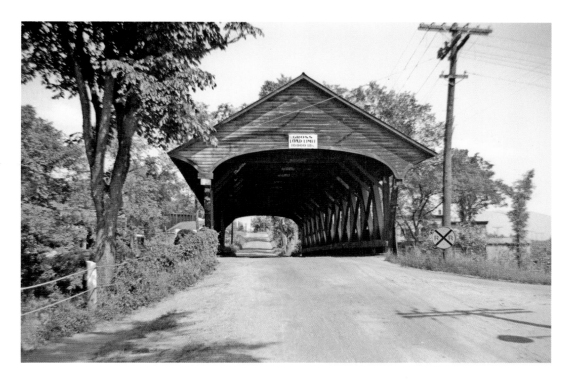

A BRIDGE IN TOWN: Mechanic Street Bridge has crossed Israel River near downtown Lancaster since 1862, although it has been extensively rebuilt. Local drivers apparently respect the posted clearance, since neither photograph shows any evidence of damage from overheight trucks.

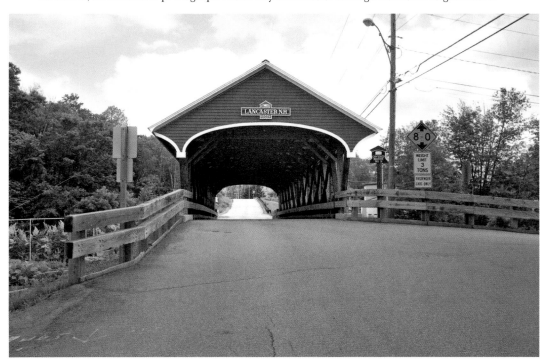

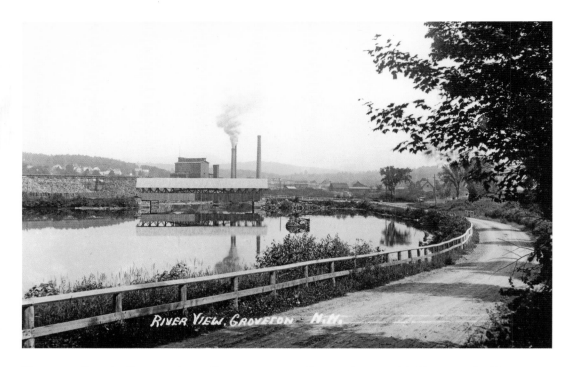

**COVERED BRIDGE SURVIVES ITS REPLACEMENT:** Groveton's covered bridge over the Upper Ammonoosuc River was built by Captain Charles Richardson in 1852. It served busy U.S. Route 3 until being bypassed in 1939, and it has since outlasted its steel replacement. The former Groveton Paper Company mill in the background went through a succession of owners over the years, but is was closed by 2013.

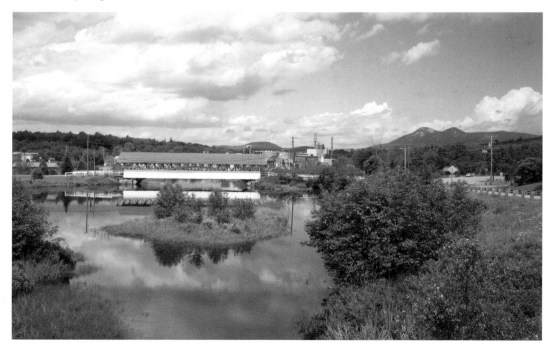

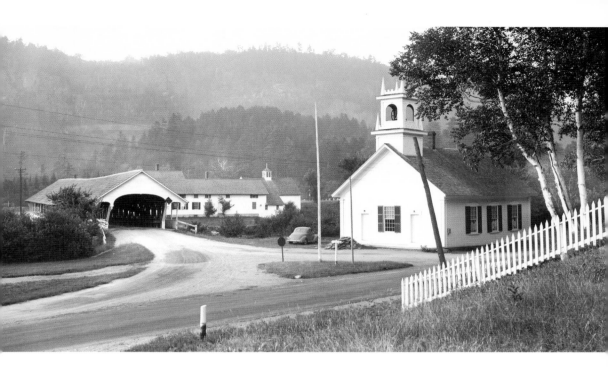

A BRIDGE MUCH PHOTOGRAPHED:  Stark's covered bridge is famous because of its lovely location next to a traditional New England church, under an impressive cliff. The town buried the utility wires in the foreground in order to improve the view. Henry Gibson's 1948 view shows a significant sag which was later stabilized, but the bridge is scheduled for a major restoration.

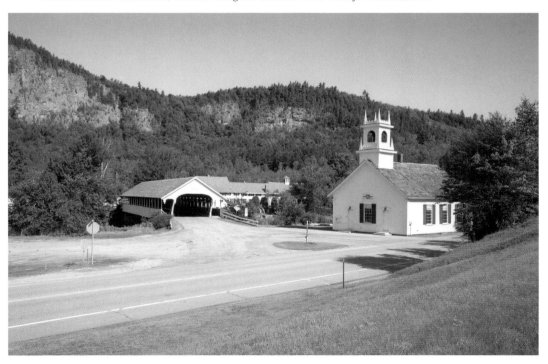

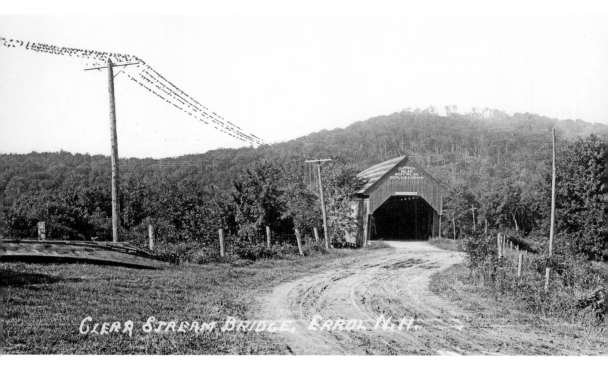

LONG-GONE LANDMARK: Clear Stream Bridge in Errol, at the head of the famed 13-Mile Woods, was replaced in 1938 by a steel pony truss, which itself has recently been replaced. The only detail left from the old view is the profile of the distant hillside.

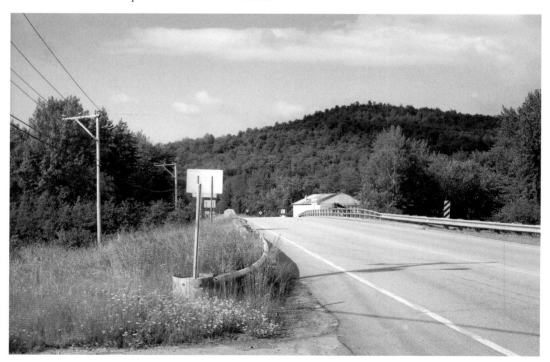

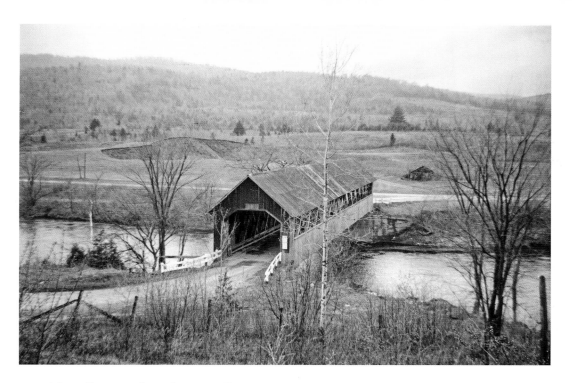

MOST RECENT OLD COVERED BRIDGE: Columbia Bridge, over the Connecticut River south of Colebrook, dates from 1912 and was the last old historical covered bridge built on a New England road. It remains in good condition, carrying traffic between Columbia, New Hampshire and Lemington, Vermont, at the time of the picture.

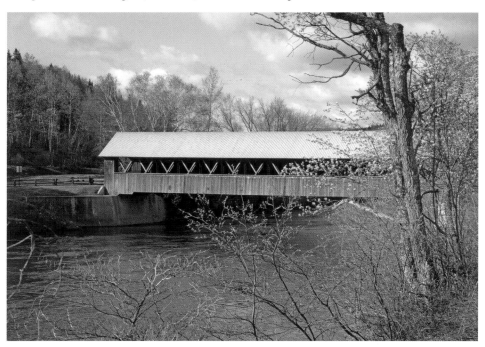

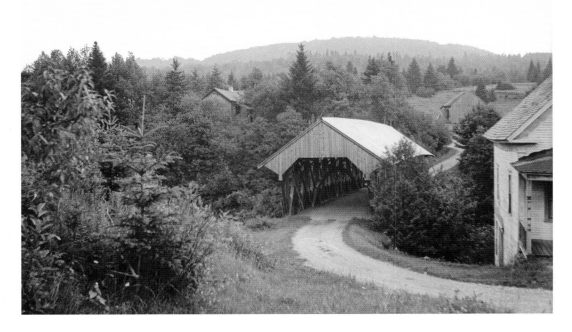

NORTHERN NEW HAMPSHIRE BRIDGE: Pittsburg-Clarksville Bridge has been out of service since 1981, and has changed little since Richard Sanders Allen's view was taken in 1938. It is not in good condition, but it is interesting because it has not been modified by any efforts to update it for modern traffic. It crosses the Connecticut River, which at this point is entirely in New Hampshire.

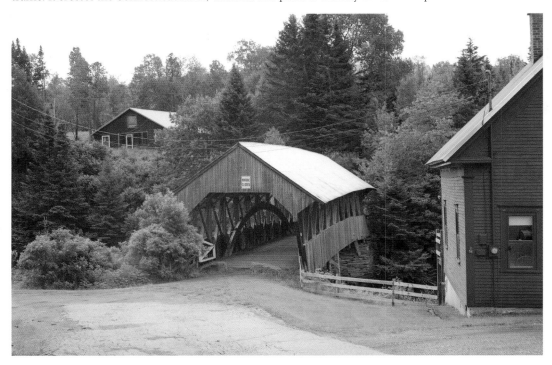

# MAINE AND A POSTSCRIPT

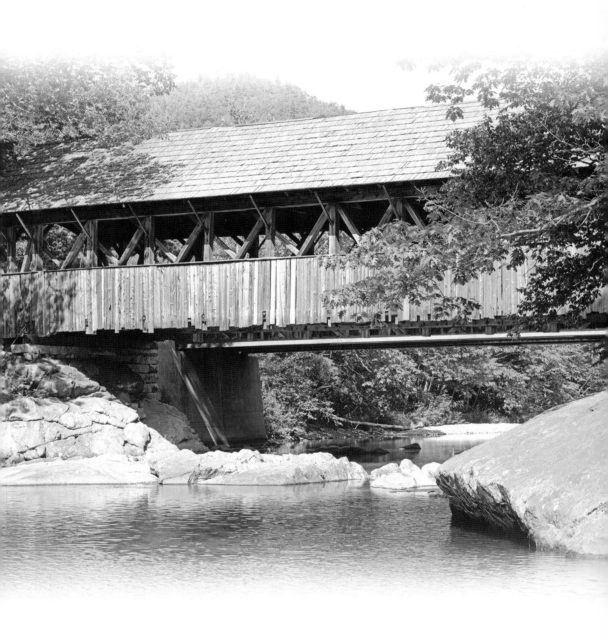

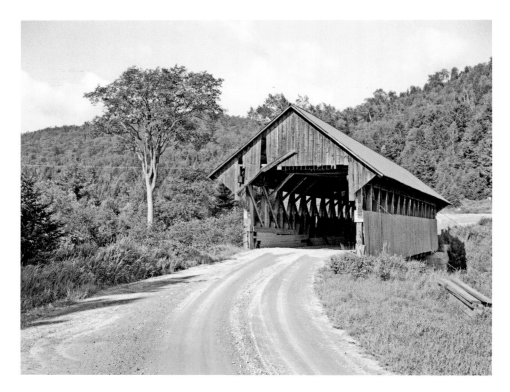

BRIDGE IN MAINE'S WESTERN MOUNTAINS: Maine has never had as many covered bridges as the other states of northern New England, but Bennett Bridge still crosses Magalloway River at the south edge of Wilsons Mills. It has been closed to traffic since 1985, and was the subject of a sensitive restoration by master framer Tim Andrews in the early twenty-first century.

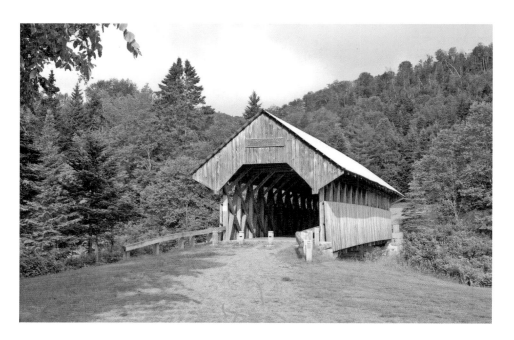

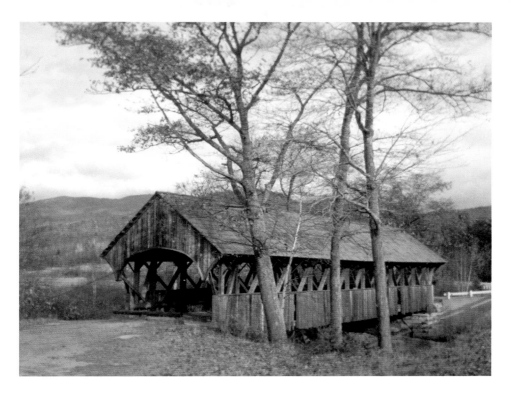

POPULAR WITH ARTISTS: Sunday River Bridge in Newry was closed, but the state has kept it in excellent repair; the fact that it does not have to carry modern traffic means that it is fairly close to original condition. The growth of trees is the only obvious change between the author's 1973 and 2013 photos (page 91 shows a side view). Maine owes much to the vision of Roy Wentzel from the State Highway Commission, who in the 1950s was one of the few engineers in the country working actively for covered bridge preservation.

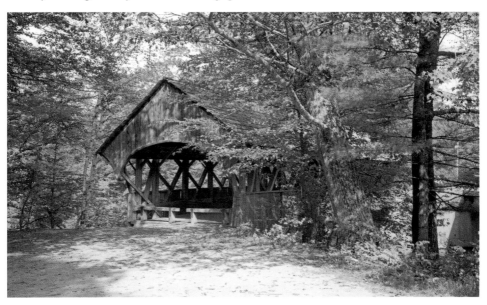

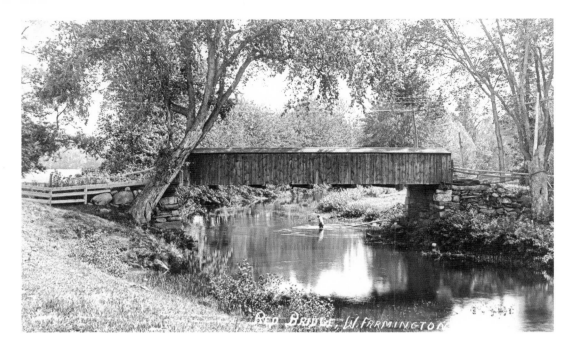

BYGONE BRIDGE TYPE:  Timber pony trusses, boxed on the sides but with no roof, were once common on New England roads. Although closely related to covered bridges historically, they lacked popular appeal, and have become very rare. This example crossed Temple Stream in West Farmington. The site in 2013 includes busy Wilton Road, Routes 2 and 4, and carries constant traffic in four lanes.

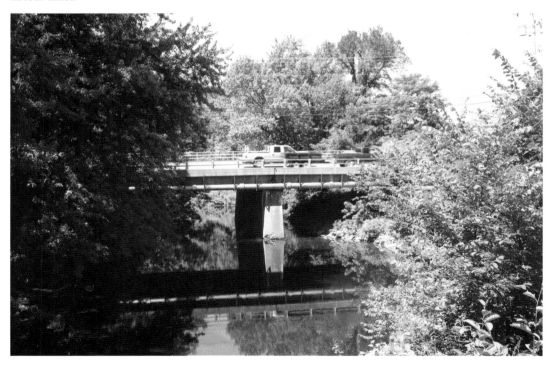

94

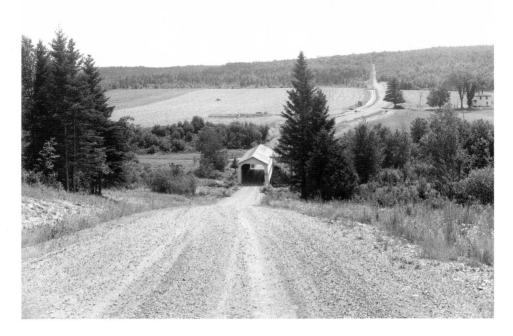

CHANGE JUST OVER THE BORDER: A postscript: The Eastern Townships region of Québec shares cultural history with New England, including covered bridges. The landscape around the Willis Leggett Bridge near Saint-Isidore-d'Auckland documents the dramatic changes that have also transformed the New England states. The author's July 1975 photo shows an active farm, with haying under way, and a traditional farmhouse shaded by old elms. By July 1985 the elms were gone, the farmhouse has been remodeled, and the back of the field has been planted to trees.

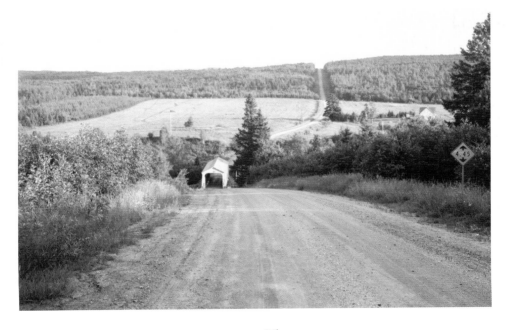

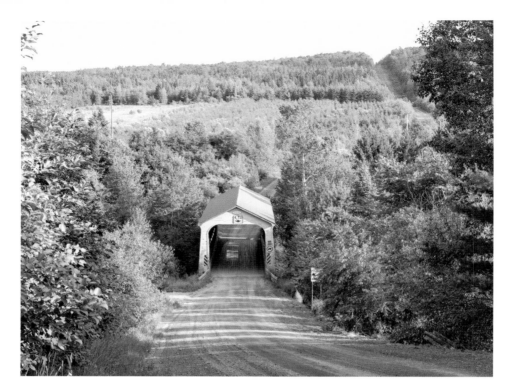

GONE BUT NOT FORGOTTEN:  Willis Leggett Bridge still stood in July 1995, but the surroundings were reverting to forest. Another portion of the former hayfield has been planted to trees, although a close look would reveal heavy weevil damage. The covered bridge was lost to arson in 2001 and a modern bridge replaced it. Our July 2005 photo shows an entirely different landscape.

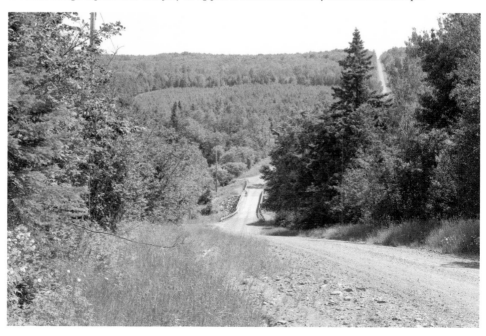